IMAGES
of America

BAYTOWN

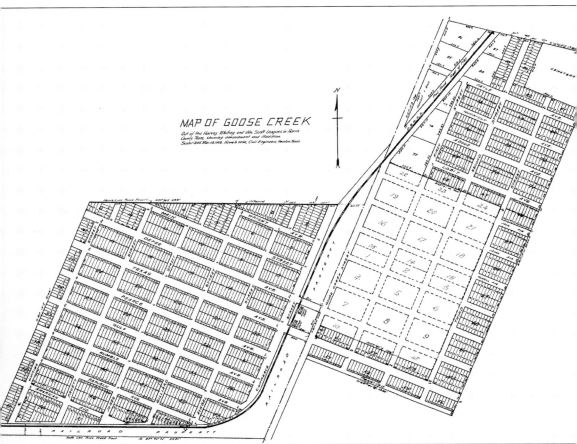

MAP OF GOOSE CREEK

Out of the Harvey Whiting and Wm Scott Leagues in Harris
County Texas, showing amendment and Subdivision.
Scale 1:600, Mar.18,1918. Home & Wike, Civil Engineers, Houston,Texas.

In 1916, Anna and George Wright dedicated 40 acres for the new town of Goose Creek. This is shown on this plat as Blocks 1–24 on what became known as the Goose Creek Town Site. In November 1917, the Goose Creek Realty Company, headed by W.T. Terry, purchased land from Price Pruett and extended the town west of the railroad to Whiting Street. In 1927, Ross Sterling started his realty company, Sterling Properties, and purchased all the unsold lots in Goose Creek. This map of the new town of Goose Creek in March 1918 shows the original street names before many of them were renamed in 1948. (Courtesy Harris County Archives.)

ON THE COVER: The Hog Island Ferry and causeway bridge opened in 1933 and became part of Texas State Highway 146 in 1936. The ferry provided an expedient south entry to the Tri-Cities, cutting an hour off the trip, which previously routed across the Lynchburg Ferry. The Hog Island Ferry remained in operation until the Baytown Tunnel opened in 1952. In 1983, Hurricane Alicia destroyed the mile-long causeway bridge to Hog Island, and in 1995, the tunnel was replaced by the Fred Hartman Bridge. (Courtesy Texas State Library.)

IMAGES
of America

BAYTOWN

Chuck Chandler
Foreword by Wanda Orton

ARCADIA
PUBLISHING

Published by Arcadia Publishing
Charleston, South Carolina

Printed in the United States of America

Library of Congress Control Number: 2022942989

For all general information, please contact Arcadia Publishing:
Telephone 843-853-2070
Fax 843-853-0044
E-mail sales@arcadiapublishing.com
For customer service and orders:
Toll-Free 1-888-313-2665

Visit us on the Internet at www.arcadiapublishing.com

This volume is dedicated to all the past Baytown historians and photographers who have preserved Baytown's rich history through their writings and illustrations in newspapers and books.

CONTENTS

FOREWORD

Places and faces from the past—pictured in this first book from *Baytown Sun* columnist Chuck Chandler—take us on a tour of local history while the caption-writing author serves as our tour guide. Years of research—starting with an interest in genealogy that spread to history in general— laid the foundation for this book as well as for Chuck's newspaper column and writing narratives for historical markers. For any project or question pertaining to history, Chuck has become the man to call in his hometown—Baytown, the town of bays at the foot of the Houston Ship Channel.

When Chuck began writing history articles for the *Baytown Sun*, I began clipping and saving. So far, I have filled two file boxes with his columns and have replaced worn-out scissors with a new pair—a small price to pay for the enjoyment and enlightenment found in the reading material. Chuck is a history detective, discovering and disclosing details that may have been hidden or overlooked through the years. Superficiality is not his style; he never takes anything for granted, never takes the easy way out. Instead of merely raking the leaves of history, he plows deeply into the facts.

Family stories passed down from both of his grandmothers inspired an interest in genealogy, but in school, Chuck took history only because it was required. The subject seemed like an exercise in memorization. Later, during his service in the Navy, he began to take an interest in military history.

Chuck learned how to research while studying his family history, poring through microfilms and paper documents, becoming familiar with county courthouse and other archival records.

In researching history in general, Chuck recommends drawing on as many sources as possible and comparing findings across the board. "With more and more primary sources becoming available as digitized documents," he said, "research is becoming easier, more convenient and less expensive. I'm convinced that there are still lots of discoveries to be made."

His thoughts on how to make history interesting to the younger generation:

> When I was researching my 'Brickyards on Cedar Bayou' historical marker narrative, I enlisted the help of a high school student who had a boat on the bayou. We made several trips finding old brickyard sites (we found bricks at 10 of them). The project is completed and the narrative was approved for the marker, but I still occasionally get texts and pictures saying that he found additional sites. In school, I would undoubtedly have been more interested in history if I was involved in some kind of project like that. Kids like hands-on history and like to feel that their contributions are valued.

When growing up, Chuck was not aware of the importance of the Baytown area in the historical context of Harris County and Texas. "I became interested during the mid-1980s when Margaret Henson's book came out. Texas history is required in school, but now I know that there's enough history right here in Baytown for a course of its own."

—Wanda Orton

ACKNOWLEDGMENTS

I want to thank my wife, Phyllis, for her encouragement and patience through the months of preparation for this book.

I wish to also express my gratitude to Terry Presley and the board of directors of the Bay Area Historical Society of Baytown, for without their support, creation of this book would have been much more difficult. All of the unattributed photographs in this volume come from the museum's collection.

Also thanks go to the following groups, institutions, and people who contributed photographs, research data, and illustrations: Baytown Fire Department, *Baytown Sun*, Cecil Newton, Denise Reineke Fischer, Faith Presbyterian Church, Harris County Archive, Harris County Library, Harry Ransom Center at the University of Texas at Austin, Houston Metropolitan Research Center, Jake Daniel, Jeanie Currie, Jimmy Epperson, John Robinson, Kay Hester, Kenny Wright, K'nesseth Israel Synagogue, Mike Sheets, Portal to Texas History, Reed Woodcox, Fondren Library, Rosenberg Library, Shirley Damron, St. Joseph Catholic Church, Star of the Republic Museum, Sterling Library, Texas Energy Museum, Texas State Library, the National Railway Historical Society, Vicki Fayle, Wybra Wooster Holland, the Chambers County Museum at Wallisville, and the Westphalian Economic Archives Foundation in Dortmund, Germany.

Special thanks go out to Wanda Orton, whose historical columns in the *Baytown Sun* sparked my interest in local history, and to the late Trevia Wooster Beverly, who for several years has encouraged my research and writing.

INTRODUCTION

People have lived in the Baytown area for thousands of years. When the first Europeans arrived in the 1700s, the area was populated by the Akokisa people. They made ceramic pottery, which today is classified by archeologists as "Goose Creek style," so named because that was where it was first identified. The style has been found from the Sabine River to the Colorado River. The Akokisa spent the summers subsisting on tubers, shellfish, and the occasional deer or bison, and during the winter months, they migrated to the Katy prairie to hunt bison. In 1778, the population was devastated by disease, and by the time Stephen F. Austin established his colony in 1821, there were very few Akokisa left.

The first known Anglo settlers arrived in 1822 when Nathaniel Lynch started a ferry crossing near the confluence of the San Jacinto River and Buffalo Bayou. John D. Taylor arrived about the same time and settled at a place called Midway, so named because it was halfway between Lynchburg and New Washington, later known as Morgan's Point. He built a wharf and storehouse, and in 1824, William Scott purchased his land and improvements and built a home there that he called Point Pleasant. Because of its location, Point Pleasant became a popular stopping place for steamboat traffic, and before the Battle of San Jacinto, Juan Almonte, Santa Anna's secretary, selected this spot as his own. Another early settler was Christian Smith. He arrived in 1824 and received a league of land in Harris and Chambers Counties straddling Cedar Bayou. Dr. Harvey Whiting moved from Connecticut with his family in 1831 and settled on the east side of Goose Creek stream. (The city of Goose Creek can be confused with the creek itself, which will be referred to as Goose Creek stream, as was common practice back in the day.) Another early settler in the Baytown area was David Burnet. He brought a steam sawmill and purchased 279 acres on the Bay of St. Mary's (today's Burnet Bay). Initially, he was against secession from Mexico, but in the end, he was elected as ad interim president of the republic.

On April 21, 1836, Texas won independence from Mexico at the Battle of San Jacinto. A year later, Connecticut native Ashbel Smith arrived from North Carolina. That was the same year that Sam Houston, former general of the Texas Army and first elected president of the Republic of Texas, purchased a tract of land on Galveston Bay near Cedar Bayou that would be his summer home for many years. In 1839, after practicing medicine in Houston and treating yellow fever patients in Galveston, Ashbel Smith purchased a plantation on Goose Creek stream that he named Head Quarters. It would be a few years before he could enjoy his country home because from 1842 to 1844, he served the Republic of Texas as secretary of state, charged with winning recognition of the fledgling republic by England and France.

In December 1845, Texas became the 28th state in the Union, and Ashbel Smith returned home to settle down at Head Quarters, where he would later serve several terms as Harris County superintendent of schools. In 1847, a US Post Office was established on the east side of Cedar Bayou at Needle Point Road, and the entire area from the Trinity River to the San Jacinto River became known as the Cedar Bayou District, named for that post office. From 1845 until he purchased a new plantation called Evergreen in 1849, the voting place for the precinct was

at Ashbel Smith's log house, conveniently located on the east bank of Goose Creek stream just north of today's West Main Street.

Anson Jones, the last president of the republic, committed suicide after losing a bid for the US Senate in 1858, and his widow, Mary Jones, and their four children moved to Goose Creek, where she purchased Head Quarters. That same year, Houston dentist Dr. John L. Bryan purchased 500 acres on the west bank of Goose Creek stream. In 1859, the Baytown Post Office was established at Midway on the San Jacinto River, and a new church and school called Harmony Grove was built on his property at the east end of today's Missouri Street. In 1860, Seth Cary started a town he named Shearn on his family's land in the Christian Smith League near the Methodist church and began selling one-acre lots.

In 1847, Simon Rothschild and Lewis Cleave had purchased 3,000 acres along today's Baker Road. During the Civil War, they had a contract to supply beef to the Confederate army, and tens of thousands of cattle were butchered at the slaughter pens at Midway and shipped to Galveston. After the war, a gully crossing today's Bayway Drive just south of Bay Villa, called Packry's Branch, was dammed and a brine lake was created to pickle cow hides for shipment. From 1866 to 1868, more than 25,000 hides were shipped to Eastern ports. Frank Busch's sons bought this land, later known as the Busch Ranch, in the 1880s.

Rev. C.C. Preston opened Bayland High School in 1864 on land that he bought from Dr. Bryan and, in 1867, incorporated it as the Bayland Orphan Home. The home, administered by Supt. Henry Flavel Gillette, was built to care for orphans of the war. The first inmate, as the orphans were called, was Anna Allen. She had an ailment that required frequent medical treatment, so she moved to live in the home of Ashbel Smith, who was treating her. They would form an inseparable bond, and she became a foster daughter to the physician.

Mary Jones's family left a lasting impact on Harris County. Charles Elliot was killed in the war, but her eldest son, Samuel Edward, became a prominent dentist in Houston. Her youngest son, Cromwell Anson, served eight years as Harris County judge, and her daughter, Sarah Sophia "Sallie," married Gaston Ashe, the son of Cedar Bayou pioneer John B. Ashe. Sallie's son, Charles Elliot Ashe, would follow in his uncle's footsteps to become the second-longest-serving judge in the history of Harris County. Mary sold Head Quarters to David Wiggins in 1879, but before she did, she donated a one-and-a-half-acre tract to Harris County to build the first Goose Creek public school.

A brickyard existed on Goose Creek stream as early as 1842 and on Cary Bayou by 1863. In April 1866, William H. Gillette advertised 100,000 bricks for sale in the Galveston newspaper, made at his yard on Cedar Bayou. A new Cedar Bayou Post Office was opened near the Methodist church in 1870, and the town of Shearn became known as Cedar Bayou. Over the years, at least 20 brickyard locations operated on the bayou, and in the best years, they sent up to 12 million bricks a year to Galveston. About 90 percent of the buildings constructed in Galveston during its "Golden Age" were built with Cedar Bayou bricks. Brickmaking stopped on Cedar Bayou about 1915, mostly because the new jobs in the Goose Creek oil field paid better and had steadier employment.

Oil drilling at Goose Creek had begun in 1903 and, five years later, resulted in the first producing well on land owned by John Gaillard. As the drilling increased, a town of sorts, called Goose Creek, developed among the oil derricks. In 1913, Goose Creek became the site of the first offshore drilling in Texas, and improvements in drilling technology, notably the rock drill bit patented by Howard Hughes and first tested at Goose Creek, revolutionized the oil industry.

Everything changed on August 23, 1916, when a well was brought in making an estimated 20,000 barrels a day. Immediately, hundreds of men from neighboring fields moved to Goose Creek with their families. The "New Town of Goose Creek" had been laid out as a planned community about two miles north of the oil field with streets, homes, and a business district, and Goose Creek Realty Company was formed to sell town lots. But most of the oil field workers had no desire to attach permanent roots, so they just moved a bit north of the field onto undeveloped land owned by the children of David Wiggins. This area became known as Middle Town. And the original town that had sprung up among the oil derricks was called Old Town.

A new town site had been established north of the field, but hundreds of oil field workers and their families continued living in tents and shacks among the derricks. They had been told they would have to move if the land was needed for drilling, but most stayed put. On January 2, 1917, they did not have to be told to move when a well blew out, releasing more than 15 million cubic feet of gas per day for several days until it was brought under control. The biggest oil find, producing 35,000 barrels of oil per day, came in on August 3, 1917, on land leased from George T. Sweet and was nicknamed "Sweet Evaline." Another large producer nearby, called the "Sweet 16," and other wells in the area firmly established Goose Creek as one of the largest producing fields in the country.

Because of the nearby oil field and deep-water port access afforded by the Houston Ship Channel, Humble Oil & Refining Company president Ross Shaw Sterling chose a location on the west side of Goose Creek stream to build his new refinery. Company housing was constructed, and the town built near the refinery was called Baytown, the historical name for the area since 1859. The refinery was initially designed for an output of 16,000 barrels per day but redesigned for 60,000 before it was even started up.

On January 28, 1919, New Town incorporated, taking the name of Goose Creek. The plan was to eventually annex Middle Town into the city limits, but before that could happen, David Wiggins's son-in-law, Fred Pelly, led a petition drive to incorporate Middle Town. It became the City of Pelly on December 29, 1919.

From the beginning, there was a mixed amount of competition, comradery, and mistrust between Goose Creek, Pelly, and unincorporated Baytown. Students from the three towns all attended the same high school, and by 1927, the chamber of commerce had adopted the name of Tri-Cities. There were several consolidation attempts over the years, but each was voted down, sometimes by one city and sometimes by the other.

In 1945, the City of Pelly annexed Baytown, which set off a string of annexations by both Goose Creek and Pelly. It culminated in another consolidation election on March 8, 1947, and this time, the residents of both cities voted to consolidate. Since Pelly had the larger population, that became the name of the new city, making it the second largest in Harris County, with only Houston being larger. Many street names were duplicated in all three towns, and a large number of streets had to be renamed. As you read this book, the modern street name will be used.

A new city charter was adopted on January 24, 1948, renaming Pelly as Baytown, the name of the 1859 post office. Baytown has steadily grown, having annexed the former unincorporated communities of Wooster and Cedar Bayou. Highlands remains an unincorporated town within the Baytown Extra-Territorial Jurisdiction. Today, Baytown is the sixth-largest city within the Houston-Woodlands-Sugar Land metropolitan area.

One

EARLY PIONEERS

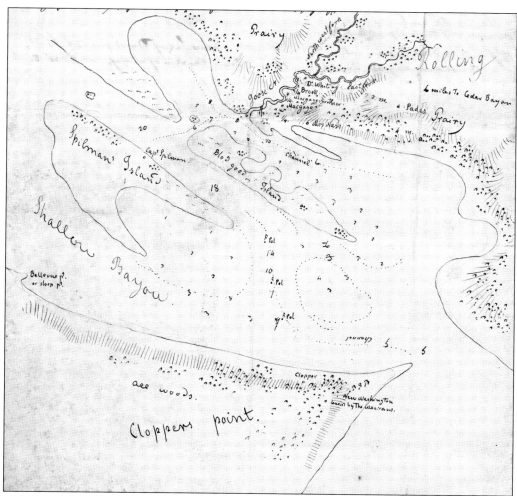

On July 9, 1836, Edward Harcourt drew this map and wrote about Goose Creek. "We visited Clopper at Clopper's Point. Confusion in the channel, and we sailed into Goose Creek Bay, which was interesting to see. The trip became wearisome, however, because we had to drag the boat through the shallow spots that were grown up in sea grass. We were overtaken by nightfall, but I discovered Goose Creek. We went up the creek some distance, and were warmly welcomed by Mr. Macgage [James S. McGahey]. The setting of this little settlement is beautiful. The next morning we continued on our expedition to Dr. [Harvey] Whiting's place. This area is all beautiful forests and fruitful prairie. Mrs. [Hannah] Nash's settlement has a higher location with a beautiful view of the bay." (Courtesy Westphalian Economic Archives Foundation, Dortmund, Germany; translated from German by Louis E. Brister.)

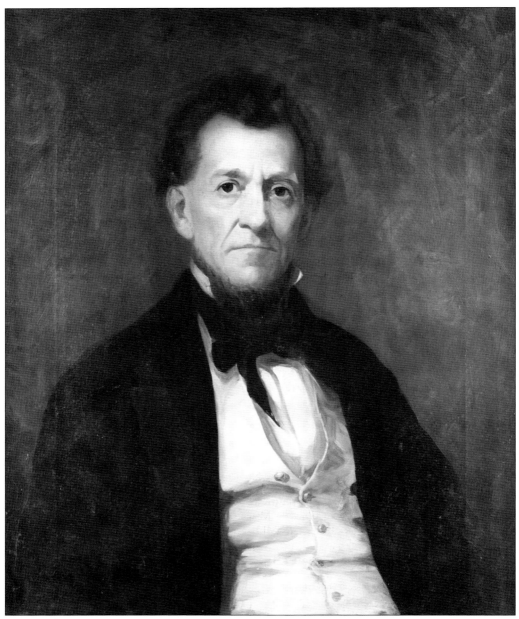

In 1837, Ashbel Smith moved to Texas, where he was named surgeon general. In 1839, after practicing medicine in Houston, he purchased a plantation on Goose Creek stream, which he named Head Quarters, but from 1842 to 1844, he lived in London and Paris, serving as secretary of state of the Republic of Texas. In 1849, he purchased another plantation called Evergreen. In 1860, when the Texas Medical College was established, he was named the first professor of surgery. After serving in the Confederacy, he returned to Evergreen and served as Harris County school superintendent. When the University of Texas was established in 1881, Ashbel Smith was named the first president, and although a former slave owner, he became an avid proponent for the education of African Americans and was chairman of the board of commissioners establishing Prairie View A&M. He died at Evergreen in 1886. (Courtesy of the William Henry Huddle Art Collection, 84.83.1, Harry Ransom Center.)

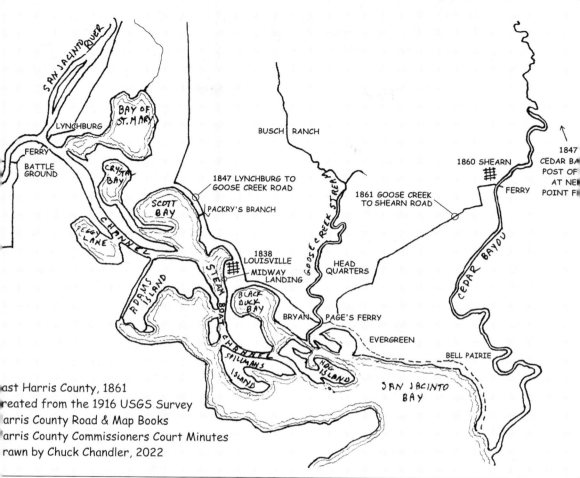

The following labels appear on the map:

SAN JACINTO RIVER
BAY OF ST. MARY
LYNCHBURG
BUSCH RANCH
FERRY
BATTLE GROUND
CRYSTAL BAY
1847 LYNCHBURG TO GOOSE CREEK ROAD
1860 SHEARN
1847 CEDAR BAY POST OF AT NE POINT F
PACKRY'S BRANCH
1861 GOOSE CREEK TO SHEARN ROAD
FERRY
SCOTT BAY
PEGGY LAKE
CHANNEL
GOOSE CREEK STREAM
1838 LOUISVILLE
MIDWAY LANDING
HEAD QUARTERS
ADAMS ISLAND
STEAM BOAT CHANNEL
BLACK DUCK BAY
CEDAR BAYOU
BRYAN
PAGE'S FERRY
EVERGREEN
BELL PAIRIE
SPILLMANS ISLAND
HOG ISLAND
SAN JACINTO BAY

ast Harris County, 1861
reated from the 1916 USGS Survey
arris County Road & Map Books
arris County Commissioners Court Minutes
rawn by Chuck Chandler, 2022

The town of Louisville was established by William Scott's sons in 1838 but was destroyed by a hurricane in 1844. Hance Baker was living at Midway in 1844 when the Methodist church was organized by Robert Alexander at his house. Midway was also the location of the 1859 Baytown Post Office. Also shown on the map are Mary Jones's Head Quarters, Ashbel Smith's Evergreen, Henry Flavel Gillette's Bell Prairie, and the town of Shearn, founded by Seth Cary in 1860. The original Cedar Bayou Post Office in Chambers County closed in 1861. During the Civil War, Franz Busch supplied beef to the Confederate army, and after the war, a dam was built at Packry's Branch. Sailing vessels shipped in tons of salt to create a brine lake where hides of cattle were brought to be pickled. From 1866 to 1868, more than 25,000 hides were shipped from here to Eastern ports. Shearn became known as Cedar Bayou when the post office there opened in 1870. (Map drawn by author.)

VALUABLE LAND AND
Plantation for Sale.

A PLANTATION of 375 acres of land, situated at the junction of the San Jacinto and Galveston Bays, is offered for sale low, for cash. The land is the very best for agricultural purposes, prod-cing for four years successively 3 hogsheads of sugar per acre, and corn 34 bushels per acre. Upon the place is an excellent two story brick dwelling with a large frame house attached; a corn mill with most excellent rocks, blacksmith shop, barns and outhouses and splendid well of water. From its situation between the bay and Goose Creek the whole tract can be inclosed with one short string of fence running from the bay to the creek. Steamboats running between Galveston and Houston, pass in full view.—Altogether, this is one of the most desirable residences on Galveston bay being well adapted to growing cane, corn or market gardening.

With the place will be sold about 1,000 head of cattle, several brood mares, horses, and a lot of hogs. For terms, apply to V. Dalton, jr., on the place; Maj. V. T. Dalton, Galveston city, or at the Crockett Printer office.

Valentine Thomas Dalton purchased 500 acres on the west bank of Goose Creek stream from the William Scott heirs in 1843. He had leased the land to start the first brickyard in the area in 1842, when he advertised 35,000 choice bricks in Houston's *Morning Star* newspaper. The land was sold to John L. Bryan in 1858 and later became the Bayland Orphan Home. This advertisement is from the March 4, 1857, *Weekly Telegraph*.

FOR SALE,

A Tract of very valuable Land, fronting on San Jacinto Bay belonging to the heirs of Gen J P Henderson dec'd. Also, The place known as Head Quarters, near San Jacinto Bay, with a front on Goose Creek—some 400 or 500 acres, with one hundred acres under fence, a small house and good well of water, belonging to H. G. Smith. Both the above tracts are well timbered and admirably adapted for cotton, etc. A particular description is not given of these tracts, as persons wishing to purchase will examine the lands.

Persons wanting to look at the places in question can apply to myself, or in my absence to my overseer, at Evergreen, on the Bay. Time will be given on both tracts. (Nov, 3—2m) ASHBEL SMITH.

In 1839, Ashbel Smith purchased 74 acres on the east bank of Goose Creek stream from Harvey Whiting, and over the next few years, he amassed a plantation of 375 acres he called Head Quarters. From 1844 until 1849, elections were held in his log cabin, located on the creek just north of today's West Main Street. This advertisement from the November 4, 1858, *Weekly Telegraph* describes the farm.

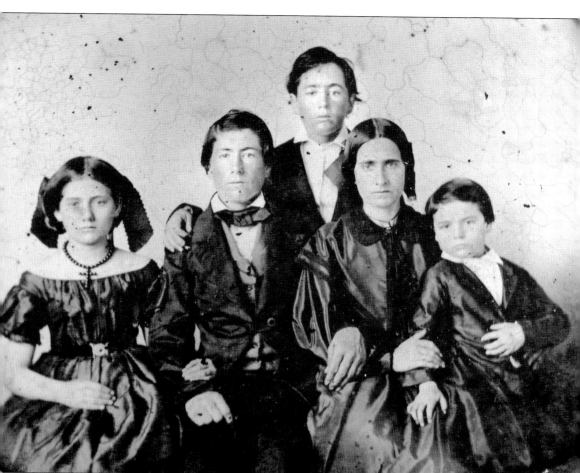

Mary Jones, the widow of Anson Jones, the last president of the Republic of Texas, moved to Goose Creek in 1859 after his death and purchased the farm called Head Quarters from Ashbel Smith. Her children were, from left to right, Sarah Sophia "Sallie," Samuel Edward, Charles Elliot, and Cromwell Anson. Sallie's son, Charles Elliot Ashe, became the second-longest-serving judge in Harris County history. Mary's eldest son, Samuel Edward, became a successful dentist in Houston. Charles Elliot was killed at the Battle of Shiloh in 1862. Her youngest son, Cromwell Anson, served eight years as Harris County judge. In 1876, she donated land to build the first public school in Goose Creek. She was the first president of the Daughters of the Republic of Texas, and her letters to her son Cromwell give a vivid picture of life in early Goose Creek. As was customary back in the day, the family is dressed in black mourning clothes following Anson Jones's death. (Courtesy Star of the Republic of Texas Museum.)

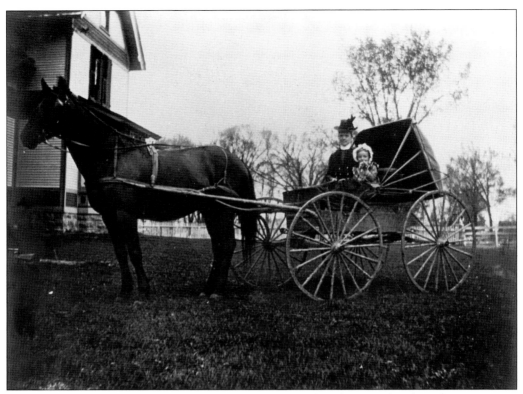

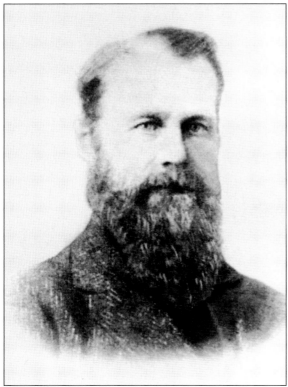

This photograph, taken about 1889, shows Linna Schilling and her daughter, Annie, in front of the Schilling home. Linna was the first teacher in Goose Creek, starting a school soon after the family arrived from Mississippi in 1867. In 1897, she and her husband, Dr. Nicholas Schilling, donated a tract of land on the east side of Cedar Bayou to start the Schilling School, which later became part of Cedar Bayou Independent School District.

Quincy Adams Wooster moved to the Baytown area in 1892, purchasing almost 1,000 acres in the Nathaniel Lynch League where he founded the community of Wooster, Texas. Over the years, Wooster grew into a close-knit community with stores, a school, and a US Post Office. The Wooster–Cedar Bayou road (later called Park Street) was established in 1897 connecting the two towns. (Courtesy Wybra Wooster Holland.)

The ravages of the Civil War left a great number of children orphaned and destitute. Rev. C.C. Preston, who had run Bayland High School for the previous three years, incorporated it as the Bayland Orphan Home in 1867. By 1871, it was home to 165 orphans. The first inmate, as the orphans were called, was Cynthia Anna Allen (pictured at right and below), who was admitted as an eight-year-old. She became a foster daughter to Ashbel Smith and lived the rest of her life at Evergreen. When oil was discovered on her property, she became one of the wealthiest women in Harris County. She could have lived anywhere she wanted but chose to remain on the farm where she grew up. Even in her old age, she still raised chickens, washed her own clothes, and tended her garden. (Both, courtesy Kenny Wright.)

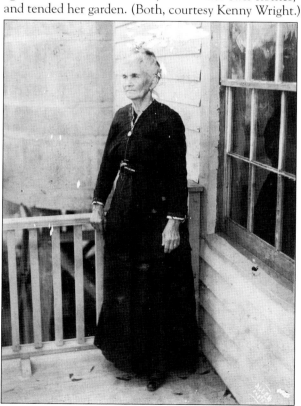

This photograph, taken about 1908, shows the John Proctor family, who lived at the end of today's Proctor Road off North Main Street about halfway between Bob Smith Road and Massey Tompkins Road. From left to right are John Proctor; his wife, Alice; Nancy; Hettie; Rebecca; and Mary Alice in front. (Courtesy Shirley Damron.)

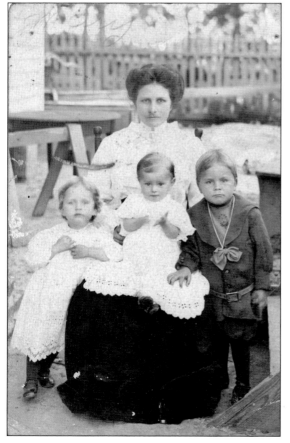

Thomas Wiggins was the only son of David Wiggins, owner of the land that later became the city of Pelly. When Thomas died in 1910, he was buried in the Wiggins family cemetery. This photograph shows his widow, Hettie Proctor Wiggins, and their children, from left to right, Nancy, Georgia, and Thomas. In 1935, the family cemetery was dedicated as the Hill of Rest. (Courtesy Shirley Damron.)

Fred Pelly, who was born in England, arrived at Goose Creek in 1895 and married Lucy Wiggins in 1898. He farmed and ranched for a living on the 73 acres her father had given her. When the City of Goose Creek tried to annex Middle Town in May 1919, he led a petition drive to incorporate Middle Town, and the new city was named Pelly. He served as mayor of his namesake city for three terms.

Ashbel Smith purchased his Evergreen plantation in 1849. This was the property most identified with him and remained his home until his death in 1886. The house shown here was notable for his collection of several thousand books. A drawing of this photograph appeared in Georgia Red's 1930 book *Medicine Man in Texas*. Her son, Walter Red, is on the left, and on the right is a local Goose Creek man, Fatty Ashwood.

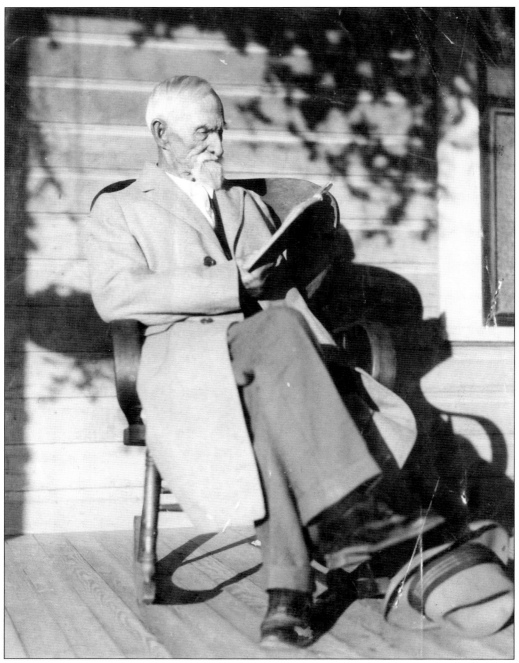

Richard Hogue Dickson moved to Goose Creek in 1850 to visit his brother-in-law, who was the preacher at the Methodist church. In later years he was known as "Grandpa" Dickson, "The Patriarch of the Tri-Cities." Grandpa Dickson was the source of much of the early Goose Creek history and died in 1931, forty-eight days short of his 100th birthday. (Courtesy Harris County Public Library.)

Two

INDUSTRY

When this map of Goose Creek was drawn in 1908, the Busch Ranch was still a cattle operation, and the days of the brickyards on Cedar Bayou were waning. The land that would later become the Humble refinery was owned by Beebe & Willard and others. It was leased by the San Jacinto Rice Company, which was chartered in 1902 and had thousands of acres from Crosby to the San Jacinto Bay in cultivation. Drilling for oil at Goose Creek began in 1903, but it was not found until 1908. A trading post called Busch Landing, which was a major wharf and trading center for the area, had been developed on Henry Busch's 20-acre tract on Goose Creek stream. The names in parentheses are the oil lease holders. (Courtesy Rice University.)

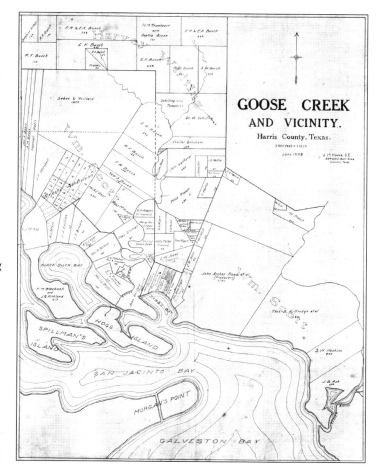

GOOSE CREEK AND VICINITY.

Harris County, Texas.

21

Ashbel Smith for a short while owned a brickyard on Cedar Bayou at a place called Devil's Elbow. It was the same yard previously owned by his nephew, William H. Gillette, who advertised 100,000 bricks for sale in the Galveston newspaper in 1866. Thomas Wright later purchased the property and moved the operation farther upstream after the 1875 hurricane.

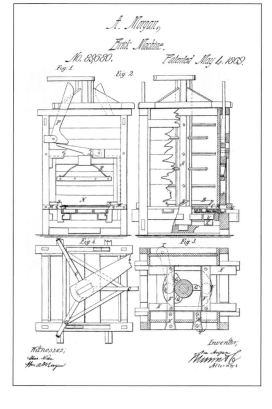

By 1870, brickmaking machines had become available, and several models were being used in the Goose Creek and Cedar Bayou brickyards. They could mix and temper the clay, press it into molds, and eject the molds from the machine automatically. This one, invented by Asa Morgan of Cedar Bayou in 1869, was assigned patent number 89,680. (Courtesy US Patent Office.)

BENJ. F. BARNES. ROB'T PALLISER.

BARNES & PALLISER,

OFFICE:

No. 114 E. Mechanic St.

Between 22d and 23d.

Bricklayers

Galveston, Texas.

—) AT (—

J. P. DAVIE & CO'S,

Adjoining Washington Hotel.

Contractors

BEST REFERENCE FURNISHED.

DEALERS IN

CEDAR BAYOU BRICK

A Superior Quality of Brick Furnished in Any Quantity, on Short Notice, and at Low Figures.

JOB WORK OF ALL KINDS PROMPTLY ATTENDED TO.

ESTIMATES FURNISHED FOR BUILDING WORK.

From 1849 through 1915, at least 20 brickyards operated on Cedar Bayou, although not all at the same time. The largest operation was that of Rosamond, Milam & Brother, which owned several thousand acres where it had a settlement and store for its employees. Just to the north were yards of Galveston builders Robert Palliser, Hugh Pritchard, and J.P. Davie, who owned over 1,000 acres at Needle Point. Thomas Wright's yard was just south of today's Roseland Park on Pine Gully. In peak years, they made up to 12 million bricks. About 90 percent of Galveston buildings dating from 1875 to 1900 were constructed with Cedar Bayou bricks, and newspaper accounts and advertisements from the Galveston City Directory list just a few structures that Palliser built using them, many of which are still standing today. (Both, courtesy Rosenberg Library.)

GALVESTON CITY DIRECTORY. 37

ESTATE S. G. ROSAMOND. C. M. MILAM. R. A. MILAM.

ROSAMOND, MILAM & BRO.

BRICK MANUFACTURERS

DEALERS IN CEDAR BAYOU BRICK,

—: AND :—

GENERAL CONTRACTORS

Office, Brick Levee, West Side 19th Street, Galveston.

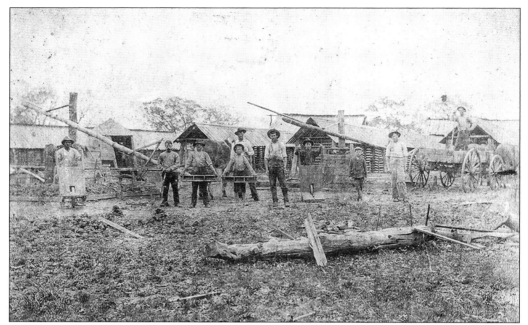

From before 1849 through 1958, Cedar Bayou bricks were exported mostly to markets in Galveston but also to Houston, Beaumont, and elsewhere. Over the years, hundreds of men and boys were employed in the various yards and hundreds more in supporting activities. This photograph shows much of the equipment used in the process, such as wheelbarrows, brick molds, pug mills, wagons, and drying sheds. (Courtesy Kenny Wright.)

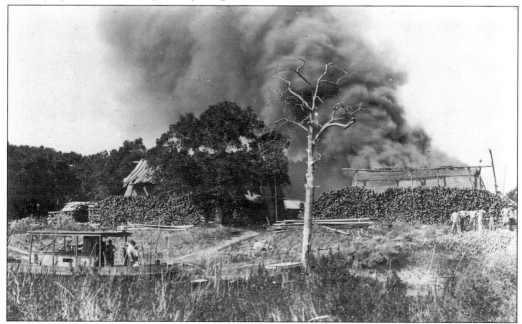

James Casey started one of the first brickyards on Cedar Bayou in 1863. With business partner Thomas Curphey, he purchased 45 acres on Cary's Bayou near Jenkins Park and began making bricks to ship to Galveston. This photograph, taken in 1914, shows the brickyard of his son, Mike Casey, located at the end of today's Cedar Avenue.

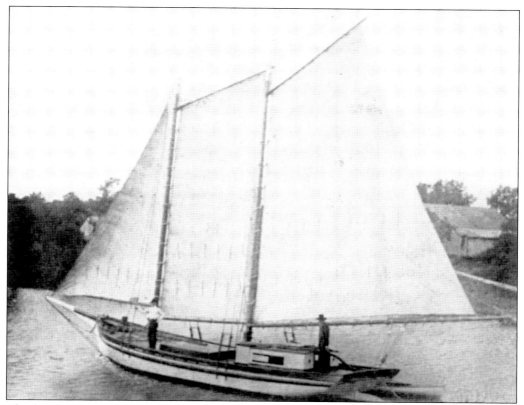

The first known commercial boat built on Cedar Bayou was the *P.J. Willis*, a 45-ton, three-mast schooner, 82 feet long, constructed in 1872 at August Ilfrey's shipyard. Into the 1890s, Ilfrey built more than a dozen schooners and steamboats for commercial use and countless smaller vessels. This 1900 photograph shows Elijah Ellisor's schooner, *St. George*, built by Ilfrey in 1879.

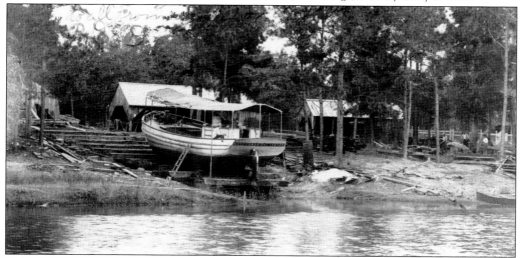

William D. Haden worked on the Cedar Bayou towpath as a boy. Schooners could not sail against the wind, so he would pass a rope to the boat and tow it by horse to the mouth of the bayou. Later, he owned a brickyard and had a shipyard. This photograph shows the *Mayflower* on the ways at his yard about three-quarters of a mile north of today's Roseland Park. (Courtesy Shirley Damron.)

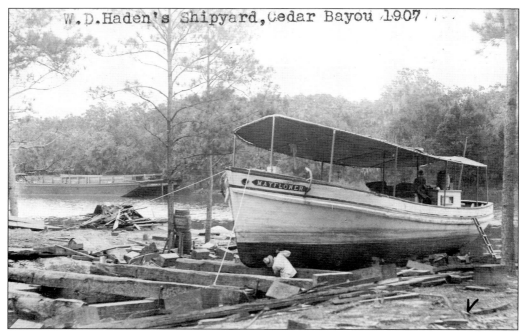

The *Mayflower* was built at W.D. Haden's shipyard on Cedar Bayou in 1900. At 52 feet long and displacing 14 tons, it was typical of the gasoline-powered vessels popular on the bay, making runs to Houston and Galveston, carrying produce there and bringing supplies back. This photograph was taken at Haden's yard in 1907. (Courtesy Denise Reineke Fischer.)

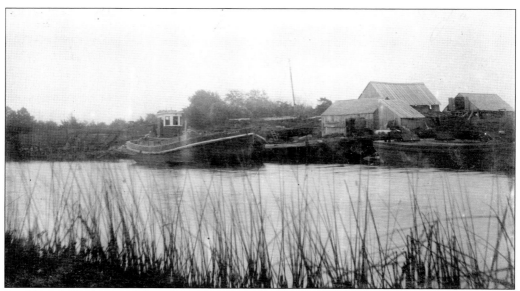

In 1908, John Kilgore purchased Haden's shipyard, across the bayou from John H. Kipp's shipyard. He started with repair work and built barges and later powered boats. No job was too big; repairs of the two-car Durain ferry and overhaul of the Lynchburg and Pasadena ferries were done at his yard, shown here. The boat in the water is the *Mary Alma*, built at William Icet's shipyard at Cove, Texas, in 1904. (Courtesy Denise Reineke Fischer.)

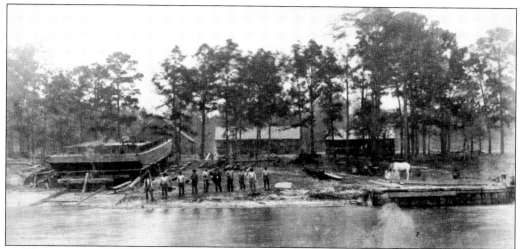

Besides sail- and motor-powered boats, shipyards on Cedar Bayou produced several barges between 1892 and 1914. The barge in this photograph was built for W.A. Guyton and Company at John Kilgore's ship yard, and the photograph probably dates from 1914 because three barges were constructed that year.

In 1923, brothers Thomas (left) and J.W. Garth (right) purchased farmland near Highlands from their uncle, H.C. Tyrell, and started Elena Farms. They began by planting 500 acres of fig trees. The venture was wildly successful, and in 1930, the orchard produced 800,000 pounds of figs. To pick the fruit, they hired migrant Mexican workers who lived in a temporary community called Camp Garfield in the 1930 census.

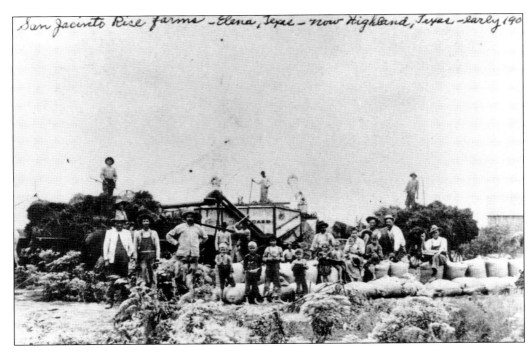

San Jacinto Rice farms — Elena, Texas — now Highland, Texas — early 190

In 1902, the San Jacinto Rice and Irrigation Company purchased and leased thousands of acres and built a pumping station near a town it named Elena. It drew water from the San Jacinto River to supply rice fields through 10 miles of main canals and another 10 miles of lateral canals. The 16,000 acres of farmland stretched from Goose Creek to Crosby. After several years of successful production, the intrusion of saltwater into the river due to dredging and the later pollution from oil drilling severely affected production, and in 1918, a large tract was sold that became the site of the Humble refinery. In 1920, the company wanted to dam the river, and failing in this, it went bankrupt in 1923. The remainder of the land was sold to W.C. Tyrell and was developed as Elena Farms.

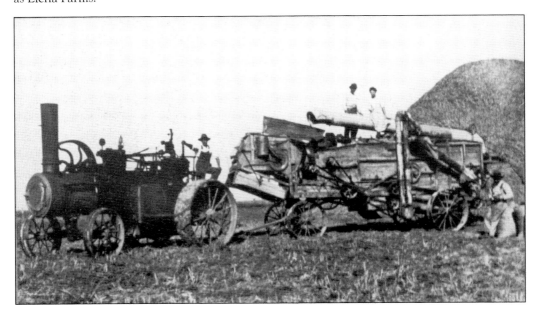

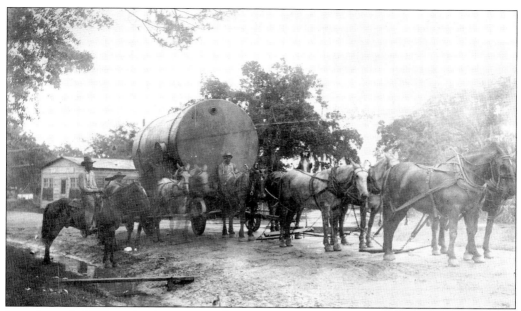

Into the early 1920s, animal power was the primary means of moving freight. They could haul wagons over mud-rutted roads where trucks could not go. In 1917, Joe D. Hughes partnered with Homer L. Davis to form the Hughes & Davis Teaming Company. Besides hauling freight, they company also graded the railroad bed from Dayton to Goose Creek and built a 300,000 barrel earthen oil reservoir. The largest teaming contractor in the South, the company employed 100 men with 300 teams of horses, mules, and oxen. Its stockyard was located on South Main Street between East Republic Street and Pelly Park. Teamsters, a blacksmith, a harness maker, and the camp cook all lived with their families on the property, and the single men lived in the boardinghouse there in what became known as the Davis Quarters. (Both, courtesy Wiley Smith Collection, Wallisville Museum.)

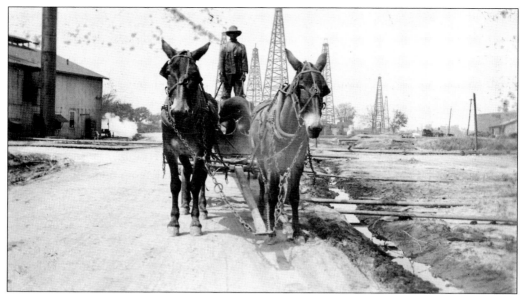

Hughes & Davis was an equal opportunity employer, hiring white, Mexican, and black men to drive teams, an unusual practice at Goose Creek in 1917. They paid $2.75 for drivers of single teams (two mules or oxen) and $3.50 for "four ups," regardless of race. This photograph shows an unidentified black teamster headed out with a load of pipe. (Courtesy Texas Energy Museum.)

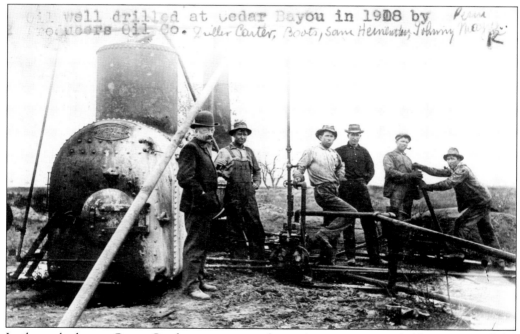

In the early days at Goose Creek, power to run the equipment was provided by steam, and the boilers like the one pictured here required fire to heat the water to generate the steam. Initially the boilers were fired with wood or coal, fed into the door at the end of the firebox, but the drillers soon realized they could use the natural gas the Goose Creek field provided in abundance. (Courtesy Denise Reinecke Fisher.)

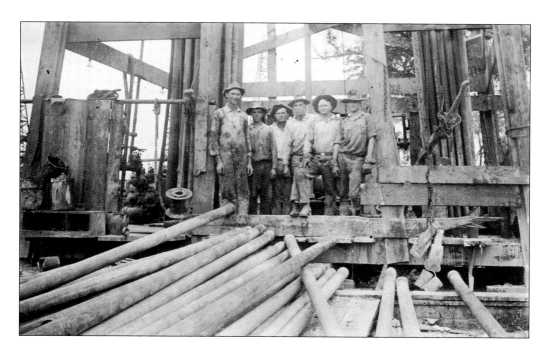

On an oil rig, the driller is the man who is responsible for the operation. He can tell from experience what is going on thousands of feet below the surface and controls the speed of the bit and the amount of force to apply from the weight of the pipe. Working for him are other experienced men called roughnecks. An operation like this also needed inexperienced laborers. These men were called boll weevils, and if they stayed on the job long enough and proved themselves capable, they could become roughnecks. A typical drilling crew consisted of the driller, two roughnecks, and two or three boll weevils. Also working was the tool dresser, a blacksmith responsible for maintenance of the drill bits for two or three rigs. These photographs show unidentified drilling crews in the Goose Creek field. (Both, courtesy Texas Energy Museum.)

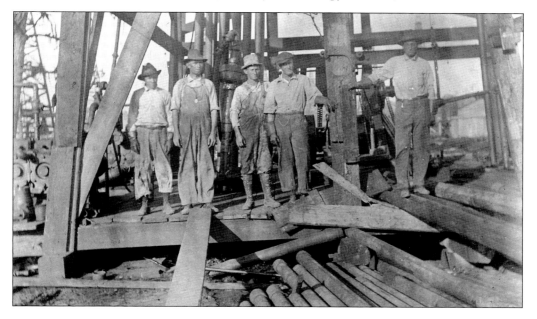

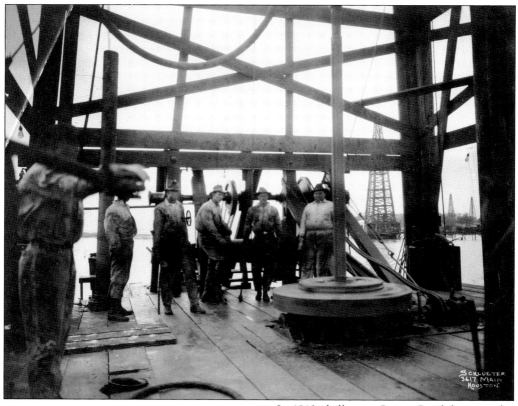

In 1913, drillers in Goose Creek became the first in Texas to drill over the water. It was more expensive to do so, but leases on land were in short supply. In this photograph, taken on the drilling platform, the rotary is driven by the unguarded chain spinning on the side. Other derricks on San Jacinto Bay can be seen in the background. (Courtesy Houston Metropolitan Research Center.)

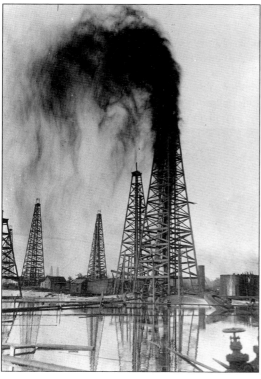

On August 3, 1917, drillers Harper & Mitchell brought in the biggest and deepest well in the Goose Creek field to date. The gusher, nicknamed "Sweet Evaline," sent oil 250 feet into the air, and the spray blew half a mile away, saturating the clothing of people in the town of Goose Creek. The gusher made 35,000 barrels a day and created a 10-acre lake of oil that averaged two feet in depth. (Courtesy Texas Energy Museum.)

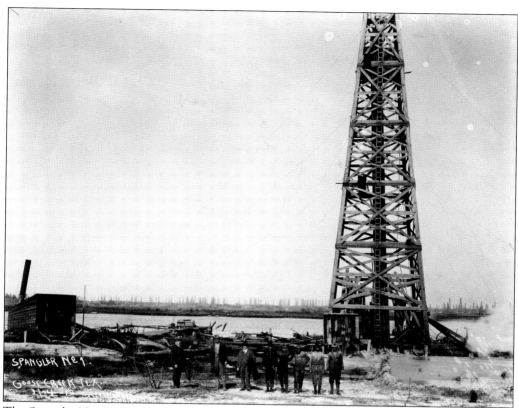

SPANGLER No. 1.
GOOSE CREEK TEX.

The Spangler No. 1 was a test well drilled on Spillman's Island to find the western edge of the Goose Creek oil field. Drilling began in September 1919 and reached 3,500 feet the following June. The derricks on the horizon were located on the mainland, on Hog Island, and in San Jacinto Bay. This was one of many wells that did not strike oil. (Courtesy Houston Metropolitan Research Center.)

Although blowout preventers were invented in 1903, they were not commonly used until years later. Pressure from natural gas could blow oil up the drill pipe and into the air, resulting in a gusher. Here, two wells are gushing at the same time, indicating that there might have been competition between the two drilling crews. (Courtesy Houston Metropolitan Research Center.)

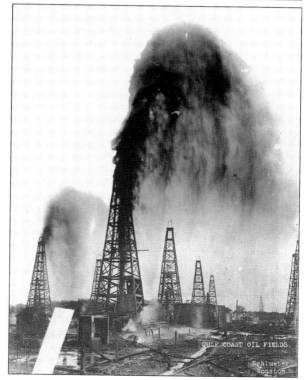

GULF COAST OIL FIELDS.

Schlueter
Houston

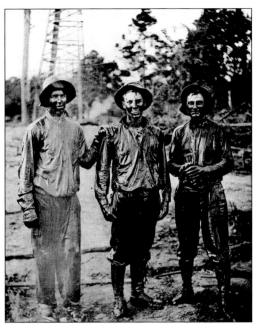

Drilling for oil was a hazardous, grimy occupation. When the drill bit reached the oil sands, a gusher of oil would usually follow, pushed up from the depths by gas pressure. Then the roughnecks, as oil workers were called, had to attach valves and piping to stop the flow. In this photograph, from left to right, J.W. Mitchell, F. Peck, and I. Miles have just finished battling a wild gusher. (Courtesy *Oil Trade Journal*.)

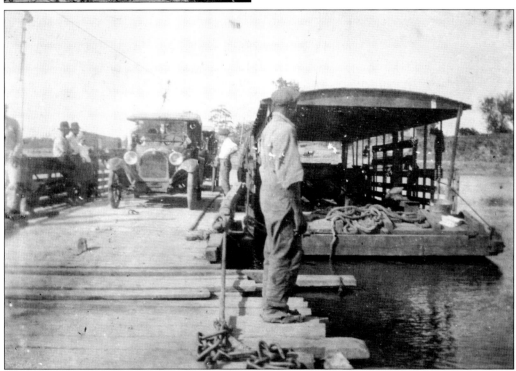

Hog Island, in the San Jacinto River, had a steamboat landing in the 1870s. A Mr. Grafton, who maintained the lighthouse on the island, also operated a bay ferry to connect the island to the mainland. When oil drilling began on the island in 1908, ferry operation resumed with the 40-passenger ferry shown on the right. The ferry on the left could have been towed over from Durain's crossing on Goose Creek. Neither had a motor; they were pulled by hand, and the trip took 15 minutes. (Courtesy Texas Energy Museum.)

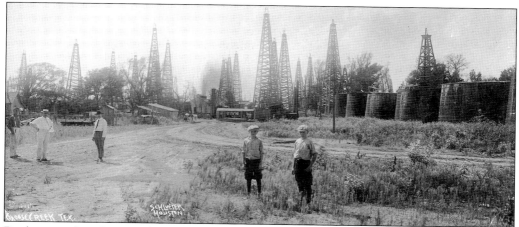

By the time this photograph was taken in September 1919, Goose Creek was an established oil field. People had moved out of Old Town, and gushers were so common that not much attention was given them. Derricks and oil storage tanks were both still made of wood. George Wright, husband of Anna Allen Wright, who owned the property, is on the far left. The other people are unidentified. (Courtesy Houston Metropolitan Research Center.)

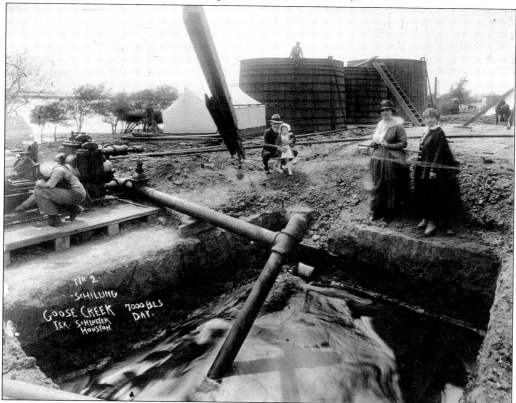

When the well on Annie Schilling's property blew out in 1917, it killed one man, spewed millions of cubic feet of gas a day, and forced the town to move. The roar could be heard in Houston, 20 miles away, but by 1918, the well was producing 7,000 barrels of oil a day. This photograph shows, from left to right, Hyram Kilgore holding daughter Roberta, Annie Schilling, and Ola Kilgore. (Courtesy Houston Metropolitan Research Center.)

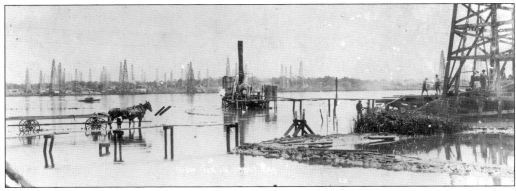

From 1916 through 1924, land in the Goose Creek oil field sank beneath the bay waters, in some places as much as four feet. Acting under a state law passed in 1913 allowing the leasing of offshore property, the state claimed the oil revenue from these newly submerged wells as public property. But a 1924 geological study and a subsequent court decision ruled against the state, saying that the subsidence was not an "act of God" but caused by the drillers themselves, to which the oil men readily agreed.

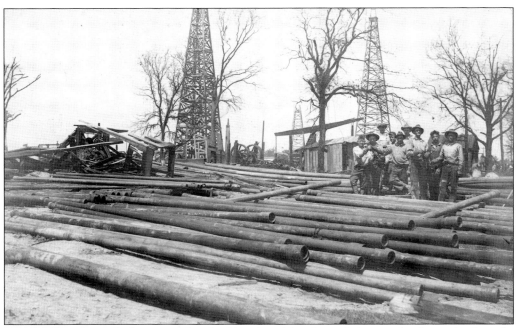

Wooden derricks took about a week to build and could withstand thousands of pounds of weight but could be brought down in minutes by a strong wind. This photograph, taken after the 1919 cyclone, shows a crew of men picking up pipe scattered from a collapsed derrick. Out of about 450 derricks, not more than 35 survived. (Courtesy Texas Energy Museum.)

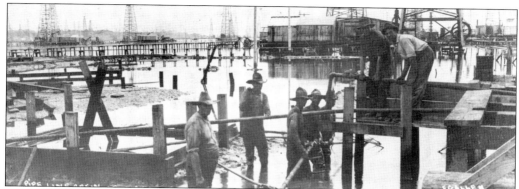

This 1920 photograph of a pipeline crew in Tabb's Bay is best told by Arthur Thalman in a 1960 interview. "They were laying a string of pipe down in a trench which was full of mud and slop. The foreman had a gang of pipe fitters, and he says, OK, all of you [expletive] with boots on get down in that trench and fit that pipe." He paused for moment, and he said, "The rest of you [expletive] get down in that ditch, too."

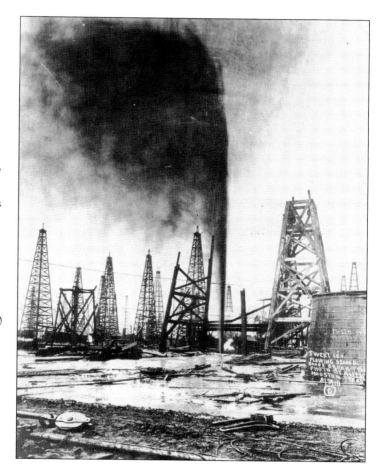

"Considerable excitement" were the words used by the reporter writing of this E.F. Simms & Company well on George Sweet's property, which blew out at the end of August 1918. It completely destroyed its derrick, as well as adjacent derricks, reaching a maximum output of 35,000 barrels per day. For 10 days, it spewed mud, water, sand, and oil over the field until it was finally brought under control. Nicknamed "Sweet 16," the well was still producing in 1984. (Courtesy Texas Energy Museum.)

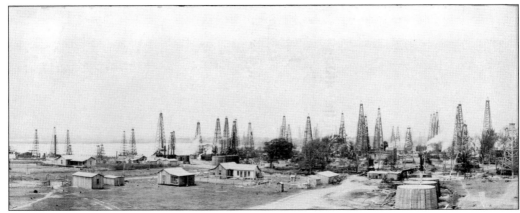

By 1917, much of Anna Allen Wright's property had been leased for drilling. She continued to live in the field but did not allow drilling near her house. This photograph shows the activity to the west of her property toward Old Town. Tabb's Bay, bordered by Gaillard's Peninsula, can be seen in the background. (Courtesy Kenny Wright.)

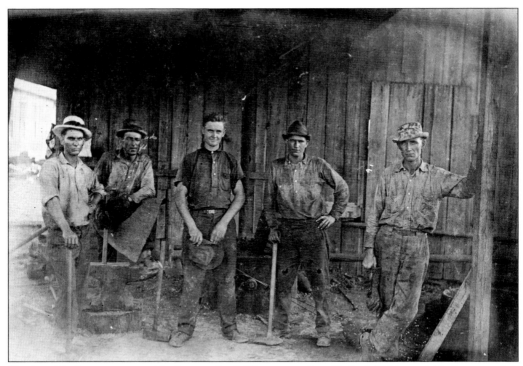

Blacksmith shops were a critical part of a drilling operation. Early drill bits quickly became dull and would need frequent rework. Special tools were needed that were usually invented and built on the spot. With few exceptions, no thought was given to patenting their inventions. This 1917 photograph shows a typical shop at Goose Creek. The man on the left is George Wright, and the man on the right was identified as Clinton Murcheon. (Courtesy Kenny Wright.)

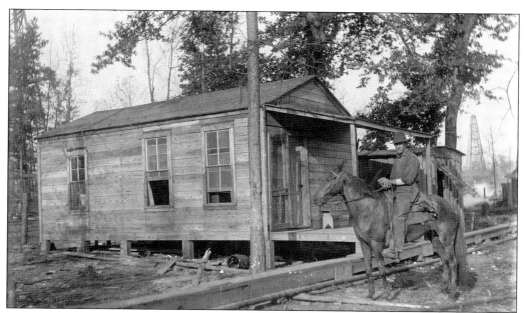

These three-room shotgun houses were popular in the oil field because they could be quickly assembled from pre-cut materials that arrived by barge and were more comfortable than tents. The floor plan led from one room to the next with no hallway. The living room was in front, bedroom in the middle, and the kitchen was the back room. Baths were taken in washtubs, and toilet facilities were outhouses.

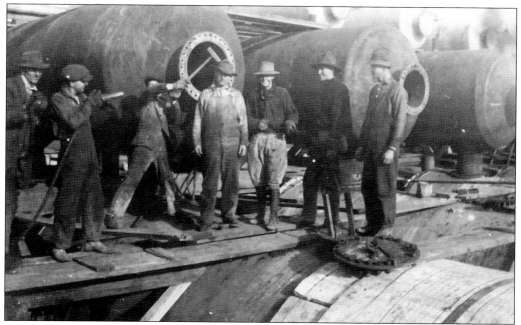

When work began on the Humble Oil & Refining Company's Baytown refinery at the start of 1919, the output was projected to be 10,000 barrels per day with 10 pipe stills. In May, construction was progressing toward a June startup, and plans were being made to increase the output to 60,000 barrels. This photograph was taken in 1919 during a lighter moment amid construction of the pipe stills. (Courtesy Texas Energy Museum.)

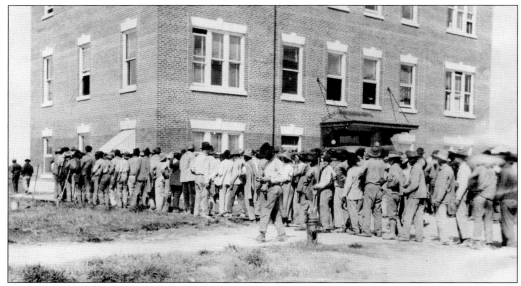

Rain or shine, hot or cold, in 1920, employees at the Humble Oil & Refining Company's refinery lined up at the three-story office building every Friday to draw their pay. It was the first brick building constructed at the refinery and stood until 1963, when it was torn down to make way for the new laboratory. The main office was moved to its later Decker Drive location in 1973.

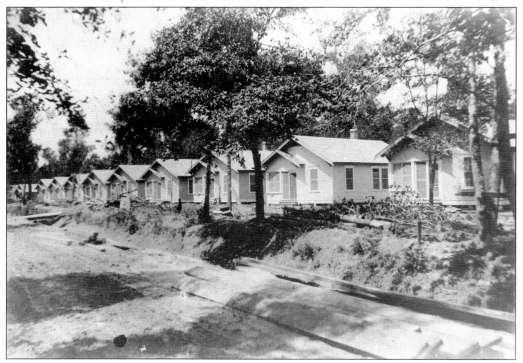

In 1919, Humble Oil & Refining Company built an entire community for its employees on company property in Baytown, complete with a civic center and elementary school. These houses had four rooms, a bath, and front and rear screened porches. When the refinery expanded in the 1950s, they were demolished to make room for oil tanks and the guard building at the south entrance to the refinery on Bayway Drive.

Three

PEOPLE AND
SOCIAL ACTIVITIES

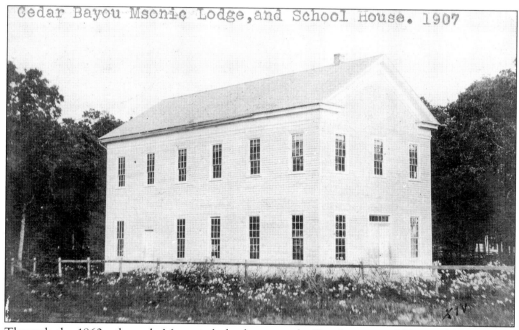

Cedar Bayou Msonic Lodge,and School House. 1907

Through the 1860s, the only Masonic lodge between the San Jacinto and Trinity Rivers was at Lynchburg, but some members lived as far as 30 miles away. When the post office was established on Cedar Bayou in 1871, the area began to grow, so Cedar Bayou Masonic Lodge No. 321 was organized in Chambers County. After meeting at the Baptist church across the bayou for several years, the Masons erected this building near the Methodist church in 1876. Lumber for the building came from Pensacola and arrived just ahead of the 1875 hurricane. Until 1911, the first floor of the lodge was used as the Cedar Bayou schoolhouse. This is the second-oldest Masonic lodge building in Texas and the second-oldest structure still standing in Baytown. It is still in use by the Masons and Eastern Star. (Courtesy Denise Reineke Fischer.)

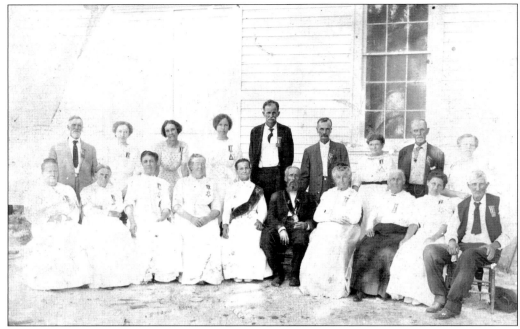

When the Grand Chapter of Texas, Order of the Eastern Star was organized in 1884, Cedar Bayou Chapter 11 was a founding chapter, and today, it is the oldest continuously operating chapter in Texas. This photograph, taken about 1911 in front of the Cedar Bayou Masonic Lodge, shows Worthy Matron Nancy Ellender and Worthy Patron Joseph Ellender in the front row surrounded by the officers. (Courtesy Shirley Damron.)

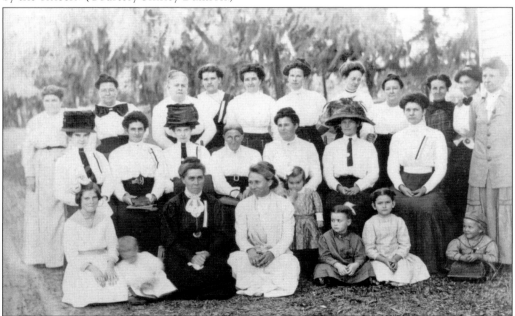

From the 1800s through the 1950s, the Women's Missionary Society was an important social and service outreach program of Cedar Bayou Methodist Church. It served the church's mission through quilting circles, ice cream socials, Bible studies, and service work. The group is pictured in this photograph taken about 1907 on the church grounds. (Courtesy Jimmy Epperson.)

Annie Schilling, daughter of Dr. Nicholas and Linna Schilling, was known as Nurse Schilling when she worked in her father's practice. She lived her entire life in the house where she grew up, across the bayou from the Methodist church. She never married or drove an automobile, but she had a ferry she used to go to church and to town. Her horse, Nelly, shown here, was bred by Dr. Leon van Meldert. (Courtesy Denise Reineke Fischer.)

This photograph of Louis van Meldert was taken by his father, Dr. Leon van Meldert, who emigrated from Belgium in 1897, followed by his family a few years later. Leon and Louis were accomplished horse breeders in the Cedar Bayou area. Leon was one of the first photographers in the area and took the pictures that were contributed by Denise Reineke Fisher and probably others. (Courtesy Denise Reineke Fischer.)

The John D. Proctor family in 1903 included, from left to right, (first row) John D. Proctor, Alice Proctor (holding baby Mary), Martha Proctor, Augusta Brooks, and Donie Proctor; (second row) Hettie and Ellen Proctor; (third row) John Proctor, Nick Gourlay, Jess Gourlay, Arthur Proctor, and Jerry Proctor. (Courtesy Shirley Damron.)

When Thomas McLean bought the store at the ferry landing on Cedar Bayou from the heirs of Joseph Lawrence in 1903, he bought the house too. This photograph from 1907 shows, from left to right, Preston Magruder Lawrence, Emma Ilfrey, Lois and Vance McLean, and Ella McLean. (Courtesy Denise Reineke Fischer.)

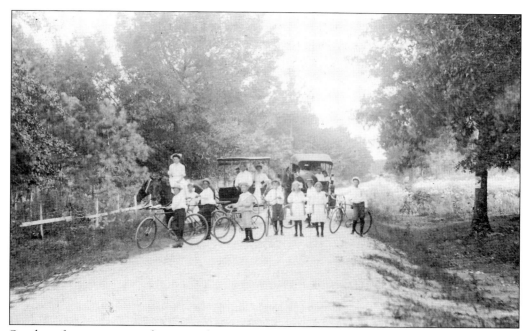

Sunday afternoon was a fine time for an outing on the Cedar Bayou shell road. This 1907 photograph shows members of the Thomas Henry McLean, Henry Pruett, and William Douglas Haden families. McLean is in the surrey on the left. He was a prominent merchant on Cedar Bayou, Henry Pruett was a stockman, and Haden was a shipping magnate. (Courtesy Denise Reineke Fischer.)

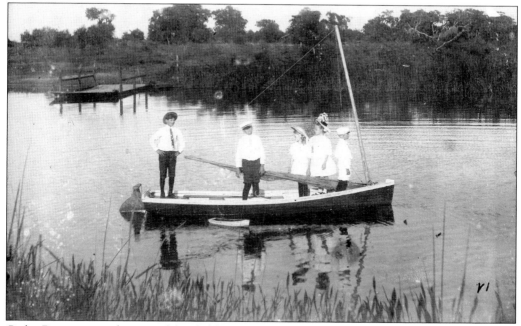

Cedar Bayou was a playground for children in the area, and they were comfortable on the water from an early age. This cat-rig sailboat is manned by, from left to right, Ivy Ilfrey, Clyde and Lois McLean, a Miss Lawrence, and Vance McLean. The ferry can be seen at the landing on the opposite shore. (Courtesy Denise Reineke Fischer.)

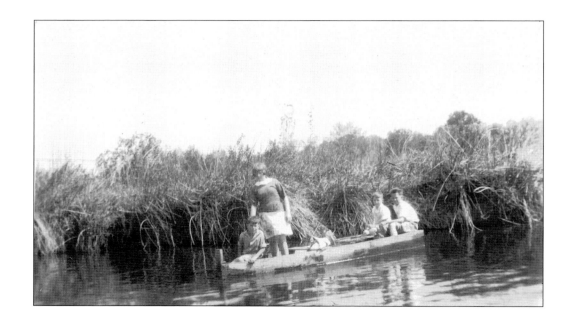

Goose Creek stream was known by that name as early as 1830, when Stephan F. Austin drew his map of Texas. Early sightings of great flocks of geese on the creek date from the earliest reports. It also became the name of the surrounding community. Goose Creek pioneer John Gaillard said that those birds were so numerous that when he and his brother hunted them in the early 1870s, they could bring down eight or ten with one firing. The creek remained a sportsman's paradise through the early 1920s, but by 1930, oil extraction, dredging, and subsidence had fouled the water and sank the marsh beneath the tide level, widening the stream appreciably. In these photographs taken just after the Market Street bridge was built in 1928, Rosa Perkins and some friends are enjoying an outing on their homemade pirogue. (Both, courtesy Susan Winifred Perkins.)

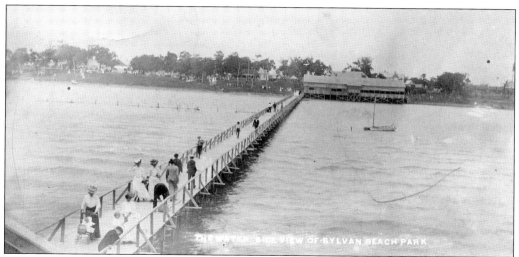

Although it was in La Porte rather than Baytown, Sylvan Beach was a favored destination for fishing, swimming, and dancing for folks in the Baytown area. It took a several-hour drive over the Lynchburg Ferry to get there, but in 1933, the Morgan's Point Ferry shortened the trip considerably. This pavilion, constructed in 1902, was destroyed in the 1915 hurricane and rebuilt. (Courtesy Kenny Wright.)

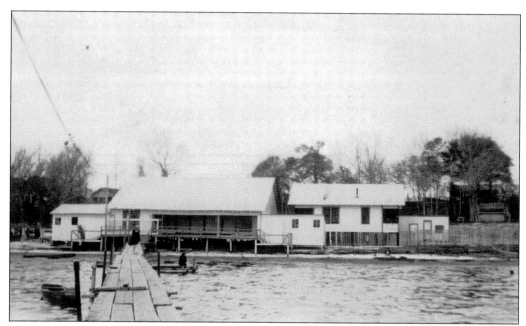

In 1931, Eric Hartman leased the Evergreen Pavilion. He put in playground equipment and enlarged the dance floor. He advertised bathing, boating, and dancing and hired the Merry Makers Orchestra from Houston to play three nights a week. All was good until the hurricane hit in 1932 and destroyed the whole resort. Evergreen Beach remained a popular destination, but after the Morgan's Point Ferry started up in 1933, people went to Sylvan Beach for dancing.

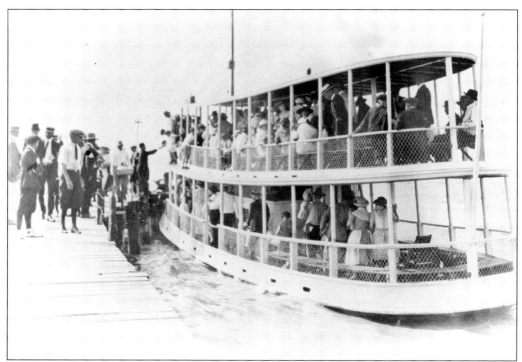

The first Humble Oil & Refining Company picnic was in 1917, and by the time the new refinery started up in 1919, it had grown to a grand affair. The first picnic at Sylvan Beach in La Porte was held in 1921 and showcased competitions among the employees and a baseball game between the Houston and Baytown employees. *Nicholaus* is shown here at the company docks preparing to leave for the celebration. After Sylvan Beach was destroyed by the 1915 hurricane, it was rebuilt better than ever. Its new dance pavilion became a popular destination for people from the Baytown area. People who did not take *Nicholaus* to the Humble Day picnic arrived by automobile from Houston or over the Lynchburg Ferry. These photographs were taken at the 1921 Humble Day picnic.

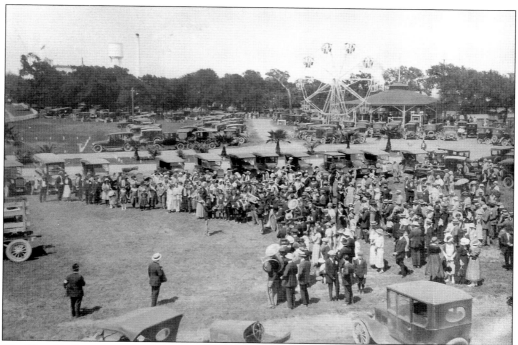

The Humble Day picnic was a tradition that has continued through the years. This picture shows the picnic in 1921. Among the events were baseball games and other sporting events, dancing in the pavilion, carnival rides, a concert by the Humble Oil & Refining Company band, and, of course, the barbecue. By the early 1940s, the picnic had moved back to Baytown and was held on the refinery grounds.

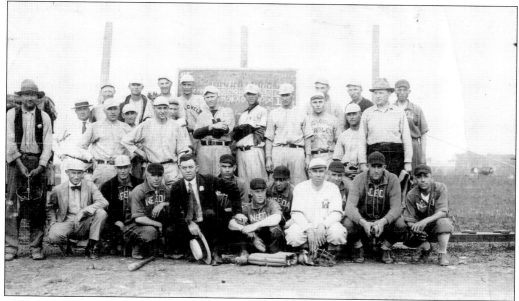

The Goose Creek Oilers began playing baseball in 1917 and developed into a pretty good team. When this photograph was taken on May 9, 1920, the Oilers had just defeated the Ineeda Laundry team from Houston 1-0. The pitcher for Ineeda, Doty Blades, in the sweater, was also the pitcher for the Houston Buffalos minor-league team.

Back in the day, sports competitions between companies were wildly popular. In 1923, the Humble Oilers baseball team consisted of, from left to right, (first row) Freddie McDonald and two unidentified; (second row) Blaise Alleman, Buddie Currie, Jeff Royder, Jack Ward, Lefty Brown, Doc Therell, "Flounder-Foot" Coker, and unidentified.

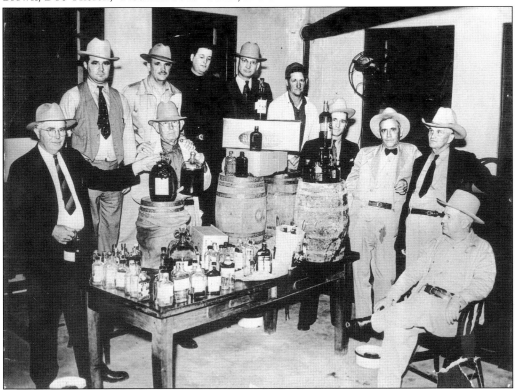

The 21st Amendment overturned Prohibition in 1933, one reason being the loss of tax revenue from alcohol sales. But despite the repeal, private stills continued as a way to get around paying the tax. This photograph shows the result of raids in Baytown, Goose Creek, and Pelly in November 1938 by state Liquor Control Board officers and local law enforcement from Harris and Chambers Counties.

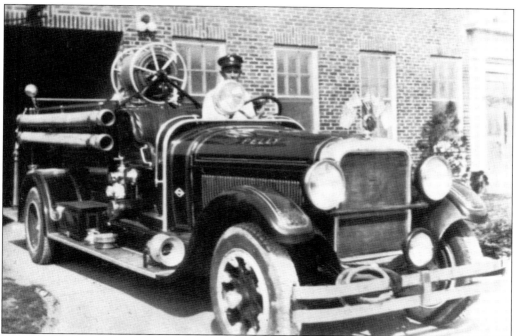

The Pelly Fire Department in 1920 consisted of a two-wheeled cart that carried a 90-gallon chemical drum with a one-inch hose. In March 1926, a new chemical fire truck was purchased and a garage for it was built behind Leggett's Drug Store. Two years later, the position of Pelly fire marshal was created, and the new city hall built that year had a garage to house the 1929 Studebaker fire engine inside the structure. It remained housed here until a new firehouse was built after consolidation of the Tri-Cities in 1947. Fire chief Q.S. Powers is at the wheel, and veteran fireman Frank Moffett is in the checkered jacket. (Both, courtesy Baytown Fire Department.)

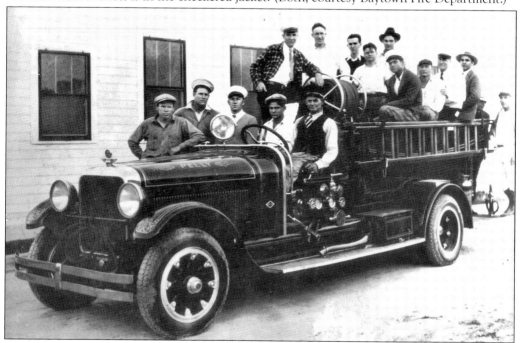

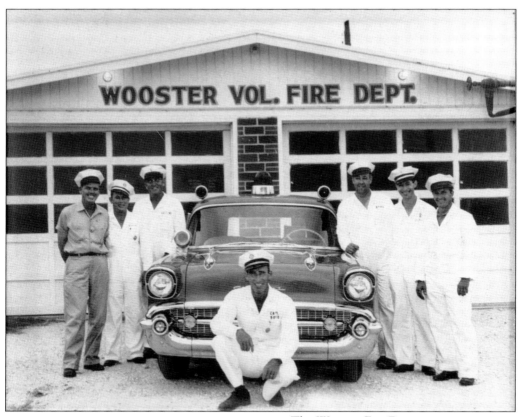

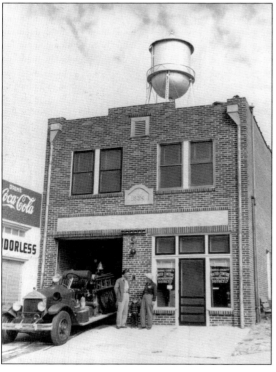

The Wooster Fire Department was organized in 1950 to serve the growing Brownwood and Wooster communities. The fire station was built on Market Street across from the Yellow Jacket Drive In on land donated by Eddie Cox and the Brown estate. The first fire chief was A.H. Lintleman. Members are, from left to right, unidentified, Louie Bishop, C.O. Collins, Capt. Jim Boyd, W.D. Moore, Eddie Whitten, and unidentified. (Courtesy Baytown Fire Department.)

When the 1859 post office was authorized at Midway, it was called Baytown. The second town called Baytown got its start in 1919 as a housing community for the Humble Oil & Refining Company. Several subdivisions were built during the 1920s, and the Baytown Volunteer Fire Department was created in 1934. Its American LaFrance fire engine is shown here at the station. (Courtesy Baytown Fire Department.)

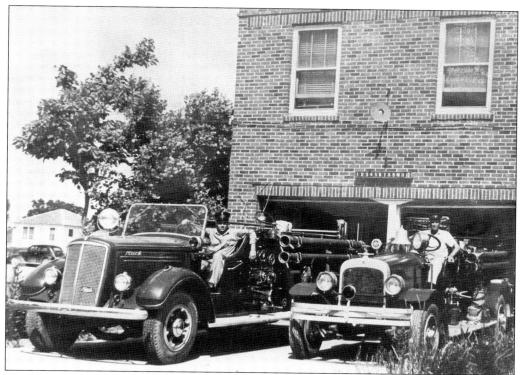

The City of Goose Creek established the position of fire marshal in October 1924 and appointed E.J. Dickens as the first man to fill the position. The fire station pictured here was built in 1929 and served in that capacity until the new fire station was constructed in 1987. The structure continues in use as the Baytown Emergency Services office building.

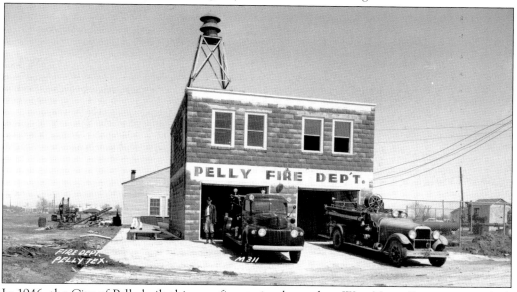

In 1946, the City of Pelly built this new fire station located on West Nazro Street, near today's Lee Drive. It could accommodate two fire trucks, and according to fire chief B.B. Elliot, "the siren is so powerful that we'll have Goose Creek firemen coming to our drills." (Courtesy Baytown Fire Department.)

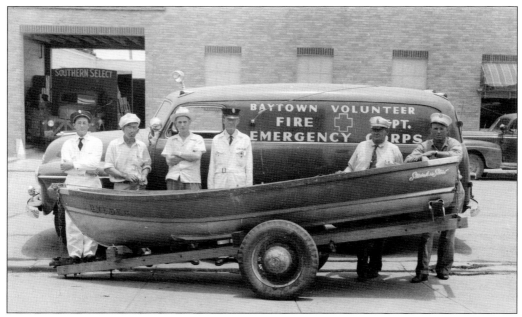

After consolidation, the area fire departments were combined into the Baytown Fire Department. The Emergency Corps, shown here with its new 1948 Chevrolet truck and rescue boat, is, from left to right, Luther Newman, Hub Bounds, S.V. Robberson, C.H. Olive, Pete Townsend, and A.H. Lintleman.

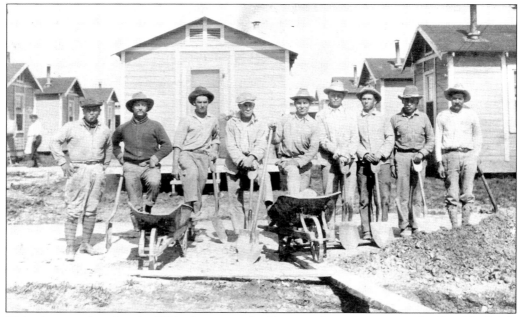

This photograph, taken in 1926, shows men building employee housing at the Humble Oil & Refinery Company in what was called the Mexican and Negro Section. The houses for single men and small families were the shotgun style, which had been popular in the oil field, and bigger families got bigger houses. The neighborhood included a community building and a playground for the children. The men in the photograph are, from left to right, Gus Torres, three unidentified, Ladislado Torres, Remigo Garia, and three unidentified.

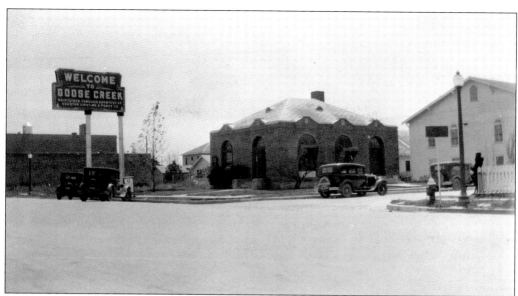

The Goose Creek branch of the Harris County Library was established in June 1921 in the office of the *Goose Creek Gasser* newspaper. Space was donated by Goose Creek businesses, but after several moves, the librarian appealed to Ross Sterling to help pay rent on a location. Instead of rent, he paid for a new building on the corner of Texas Avenue and Whiting Street. (Courtesy Harris County Public Library.)

Children's story hour was a popular outreach of the library. For several years, the librarians read stories to local children. In this 1933 photograph, 38 children listen to Betty Davidson telling the story of *How the Camel Got Its Hump*, by Rudyard Kipling. (Courtesy Harris County Public Library.)

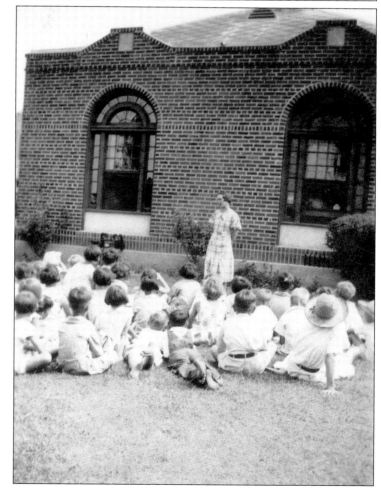

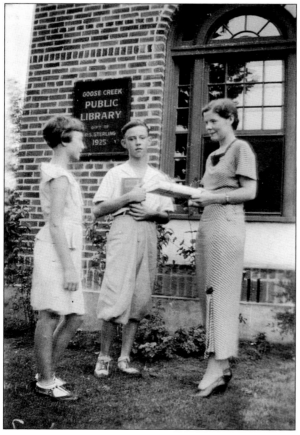

When Camp Allen outgrew its home near Sylvan Beach in 1928, Rosa Allen purchased 35 acres on Trinity Bay at Houston Point for a new site. In the beginning, campers arrived by boat, since there were no roads leading there. Over the years, more than 10,000 campers attended sessions before industrial development forced its closure in 1972. (Courtesy Harris County Public Library.)

When it opened in 1925, the Goose Creek Library was the first branch library building of a county library system in the state of Texas. It served the communities of Goose Creek, Pelly, and Baytown. After the new Sterling Municipal Public Library opened in 1964, the building was razed. (Courtesy Harris County Public Library.)

The Highlands branch of the Harris County Library opened in May 1927 in a local store with Rochelle Harris in charge of circulation. The next home for the library was a brick building shared with the post office. The library pictured here was built on a lot donated by Harry K. Johnson and opened in May 1937 with Cornelia V. Davis as librarian. (Courtesy Harris County Public Library.)

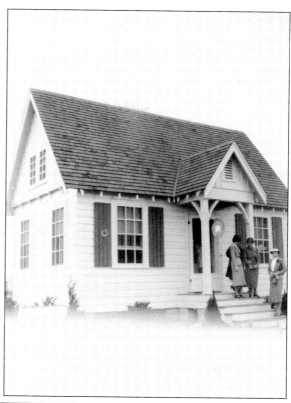

In 1923, Ross Sterling deeded a 16-acre tract of land once owned by Gen. Sam Houston to establish a YMCA for boys. The camp, known as Camp Sterling, had frontage on the bay for swimming, sailing, and fishing and had facilities for tennis, baseball, and volleyball. (Courtesy Houston Metropolitan Research Center.)

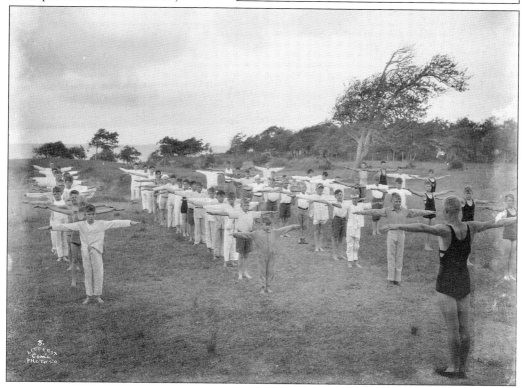

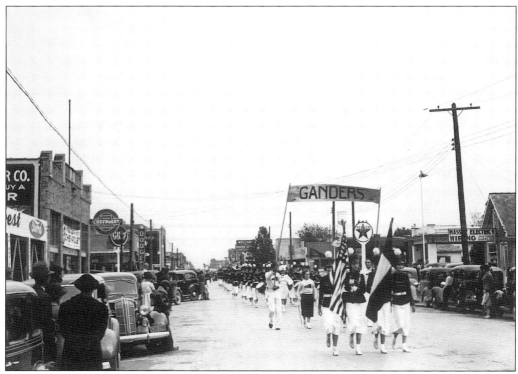

The 1936 Armistice Day activities began with a banquet at Robert E. Lee High School featuring US congressman J.J. Mansfield as the speaker. It was followed by a parade from downtown Goose Creek to the high school led by the Naval Reserve Corps of Houston. Following them were the Robert Tuck Post, Veterans of Foreign Wars, and posts from Galveston, Texas City, Pasadena, and La Porte; the Maroon Brigadiers; bands from area high schools, including Crosby and Webster; and numerous floats. They ended at Elms Field, where US senator Tom Connally delivered an address. Later, former players from Robert E. Lee and Cedar Bayou squared off in a football game, and the day ended with a dance at Miller's Inn with music provided by Eddie Bauer and his Rythmeers. These photographs show the procession from Goose Creek down Market Street.

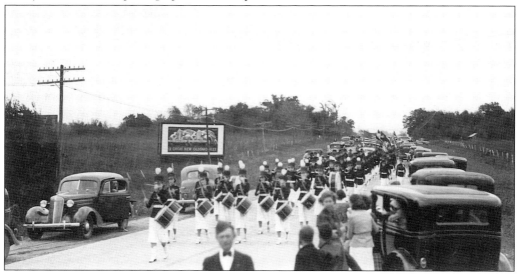

Lon Perkins was the first locomotive engineer for the Dayton–Goose Creek Railroad, built by Ross Sterling and opened to Goose Creek in 1918. Perkins hauled most of the equipment to build the Humble Oil refinery in those early days and stayed with the railroad until his retirement in 1945. He lived in Wooster and was a past master of the Dayton Masonic Lodge AF&AM. His wife, Winnie, was president of the Wooster Garden Club and served on the Goose Creek Fire Board.

The Tri-Cities were not spared from the Great Depression. When the Welfare League finance drive only received half its goal, the Red Cross, the Tri-Cities Chamber of Commerce, and numerous other organizations stepped in. Barrels were placed where people could make donations of blankets, clothing, food, shoes, fabric, and other much-needed items. This November 1932 photograph shows Jack Kuhlman (left) and Carter H. Miller (right) with one of the barrels.

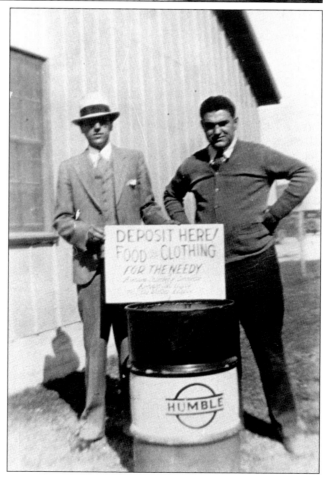

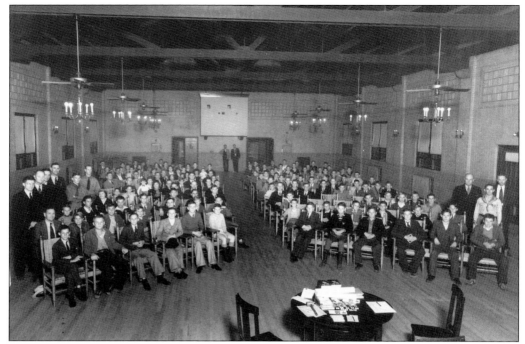

When the Boy Scout Silver Jubilee was celebrated in the Tri-Cities in February 1935, more than 100 boys from the area gathered at the Humble Community Center to hear a radio address from President Roosevelt. Afterwards, they served a chili supper to the public where they had set up camp near the library on Texas Avenue.

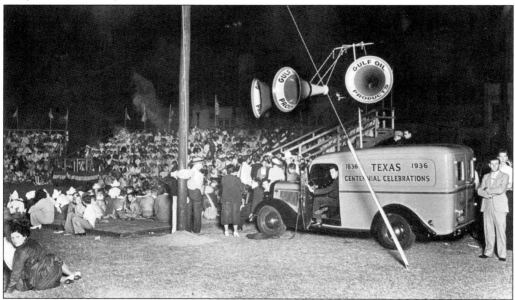

In 1935, Goose Creek Independent School District sponsored a history pageant. Students from almost all the schools in the district participated in the three-night gala, which told the history of the Baytown–Goose Creek–Cedar Bayou area from the earliest years of settlement. The script was written by Della Reeder Nelson who, when she was sponsor of the high school library club, had led a project where the students interviewed the oldest members of the community.

The pageant, part of the Texas Centennial celebrations, ran over three nights and was held at Elms Field, behind Robert E. Lee High School. It was directed by district superintendent W.R. Smith and teacher Narvella Lee Woodruff, pictured here. Narvella Lee was class valedictorian at Goose Creek High School seven years before.

In 1941, a Bathing Beauty contest at Galveston's Splash Day celebration was changed to a Car Hop Queen contest. Entrants from all over Texas included Louise Franta and Lloydine Waddell from the Yellow Jacket Inn. This photograph shows the Yellow Jacket carhops on Texas Avenue. Generia Greer is second from the left. The other ladies are unidentified. (Courtesy Jeanie Currie.)

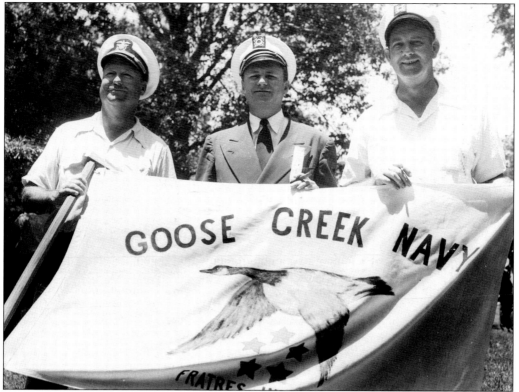

The Goose Creek Navy was a fraternal organization of Tri-Cities businessmen. Once a year, they would muster the fleet and sail to Anahuac for the annual fish fry in support of the Trinity River Project. Former Texas governor Price Daniel, center, helps Adm. Thad Felton, left, and Adm. Nelson McElroy (right) display the Goose Creek Navy flag bearing the inscription *Fratres in Mare*, "brothers of the sea."

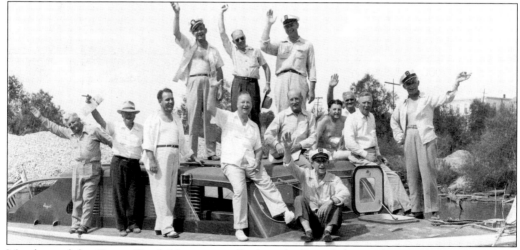

Members of the Goose Creek Navy were all admirals. From left to right are (first row) Gordon L. Farned, R. Robson, Fred Hartman, Thad Felton, and W.C. "Pop" Swain; (second row) Garrett R. Herring, Jac Jacobs, R.B. Hemphill, James Harrop, and Dr. Herbert H. Duke; (third row) Paul Braden, unidentified, and Nelson McElroy.

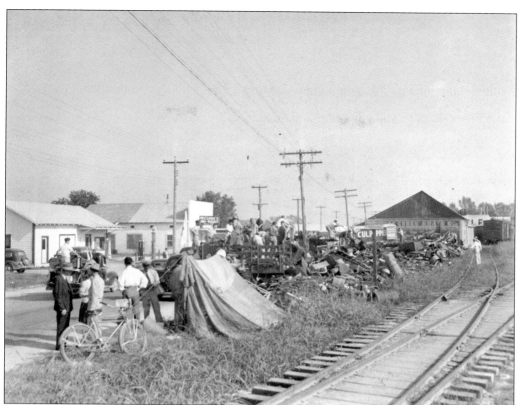

When World War II began, the United States was desperately short of steel, so in 1942, communities around the country conducted scrap metal drives. Eddie Cox was the director for east Harris County, and during that summer, over three million tons were collected. Everybody worked; even the high schools gave a holiday so 2,000 students could help. This photograph shows the collection center on North Main Street. (Courtesy Jeanie Currie.)

From 1941 through 1945, several hundred local men served in the armed forces, and 86 died in the conflict. This B-24 Liberator heavy bomber was in a squadron commanded by Pelly native Maj. Henry Dittman when this photograph was taken in 1943. He was awarded a Distinguished Flying Cross for his part in a top secret mission at the beginning of the war.

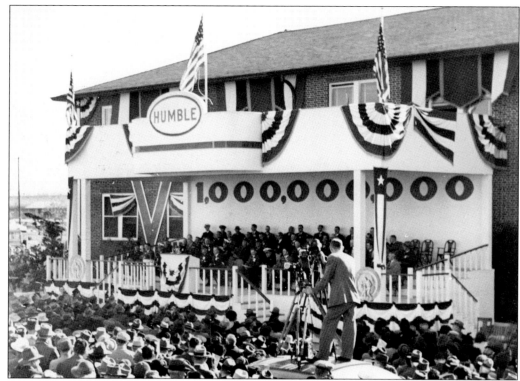

At the onset of World War II, German and Japanese warplane performance far exceeded that of the Allies. The catalytic reformation process had been just developed, which allowed Humble Oil & Refining Company to produce 100-octane gasoline. First widely used in the Battle of Britain, it gave the British planes a decisive advantage over the German Luftwaffe, which ran on 87-octane gasoline. Humble's Baytown refinery produced over one billion gallons of this high-octane fuel, which was used by Allied and American aircraft throughout the war. Other key products of the refinery were butyl rubber and toluene, used to make bombs. About half of the toluene produced during the war came from Baytown. A commemoration was held on December 14, 1944, and the Humble employees shown holding the symbolic one billionth gallon are, from left to right, W.O. Wilkes, E.C. Campbell, and J.W. Sprayberry.

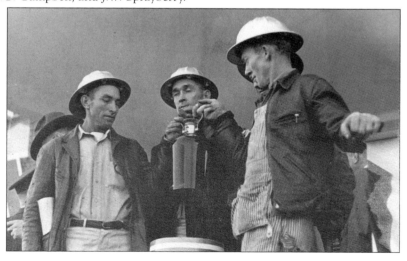

Four

TRANSPORTATION

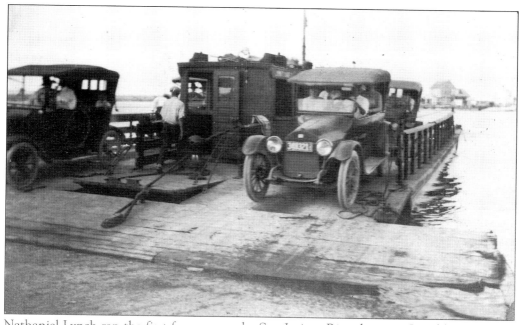

Nathaniel Lynch ran the first ferry across the San Jacinto River between Lynchburg and the town of San Jacinto in 1822. After the fall of the Alamo in 1836, thousands of panicked citizens overwhelmed the ferry trying to escape to the east, and after the Battle of San Jacinto, those thousands crossed back over. The original ferries were simply flat boats pulled across the river by hand using a cable stretched from one bank to the other. In 1911, the pull ferry was replaced by this gasoline-powered ferry with a 21-horsepower engine and a six-car capacity. It still used the cable but no longer had to be pulled by hand. After it sank a couple of times, it was replaced in 1924 by the ferry *Chester H. Bryan*. (Courtesy Cecil Newton.)

Joe D. Hughes and Homer L. Davis started the Hughes & Davis Teaming Company in 1917, serving the oil industry through the boom years. This photograph shows employees and their families with some of the livestock and wagons at their camp east of South Main Street between Republic Street and Pelly Park. Davis bought out Hughes in 1919 and continued in the teaming business in Goose Creek until his death in 1937. (Courtesy Wiley Smith Collection, Wallisville Museum.)

In 1916, when this photograph was taken, county roads in east Harris County were paved with oyster and clam shell, if they were paved at all, and by 1917, in bad weather, they were almost impassable. Gasoline launches, like these boats near the mouth of Goose Creek stream, provided reliable transportation and could dock almost anywhere. (Courtesy Kenny Wright.)

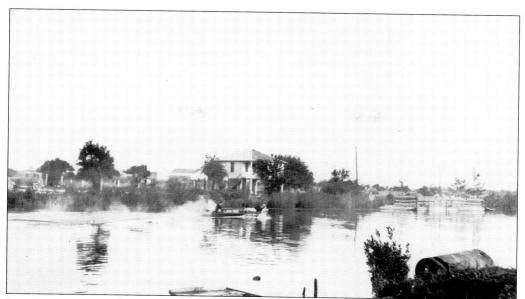

In 1878, a county road was opened along Charles Durain's south property line, and he was granted a license to operate a ferry crossing on Goose Creek stream. The crossing remained in operation until the bridge on West Main Street opened in 1931. This 1921 photograph shows the ferry. Today, the road on the west side is still called Durain Ferry Road. (Courtesy Susan Winifred Perkins.)

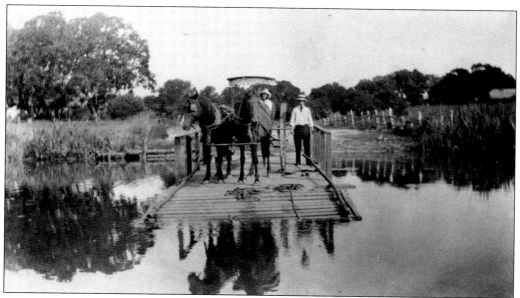

In 1859, James Evans was granted a license to operate a ferry on Cedar Bayou at the crossing near the church. Over the years, ferries crossed Cedar Bayou at no less than six different locations. The ferry near the Methodist church was the last in operation when it shut down in 1948. This photograph shows Ira and Reha Isenhour crossing on the Cedar Bayou Ferry. (Courtesy Trevia Wooster Beverly.)

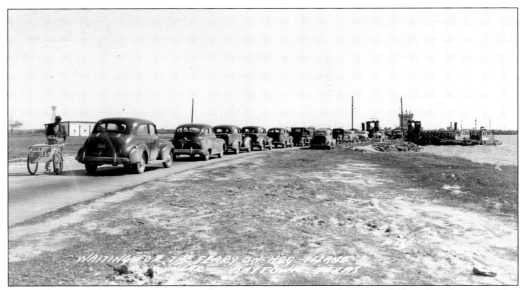

It is only two miles from Goose Creek to Morgan's Point as the seagull flies, but for years, the only way to get there by car was a 25-mile trip crossing the San Jacinto River on the Lynchburg Ferry. In 1933, a ferry was built to cross between Hog Island and Morgan's Point. A one-mile-long bridge was built from Goose Creek to Hog Island, and the ferry, named *Charles Massey*, connected the island to Morgan's Point. This became part of State Highway 146 in 1937. The wait could be arduous, but enterprising businessmen sold tamales, peanuts, and soft drinks to the waiting cars. And there were a few bars where beer was sold as well. The ferry remained in service until it was replaced by the Baytown–La Porte Tunnel in 1953. (Above, courtesy Texas State Library; below, courtesy Harris County Archives.)

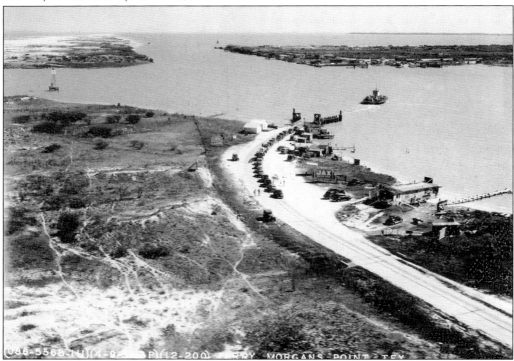

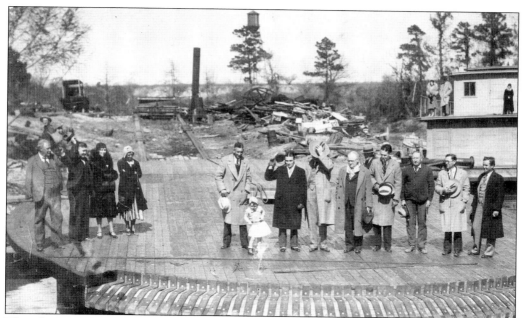

This photograph, taken in 1930 by Harris County auditor Harry Washburn, shows Rosemary Parks christening the Lynchburg Ferry with bayou water. The boat was named for her father, Harris County commissioner "Tex" Dreyfus. The Lynchburg Ferry remains the oldest continuously operating ferry in the state of Texas. (Courtesy Harris County Archives.)

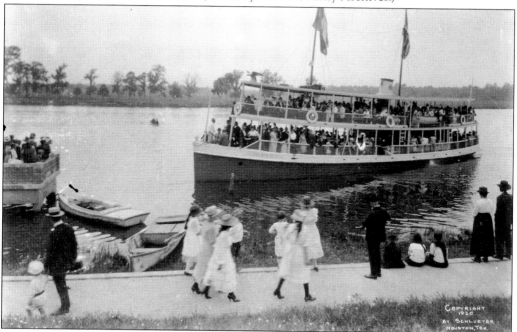

One of the more popular passenger boats was *Nicholaus*, shown here at San Jacinto State Park. Built at Wallisville in 1904, it was 86 feet long, 19 feet wide, and licensed to carry 225 passengers. At least half a dozen passenger ferries like this served towns all around the bay. For several years, *Nicholaus* made regular runs between Houston and Busch Landing on Goose Creek stream. (Courtesy Houston Metropolitan Research Center.)

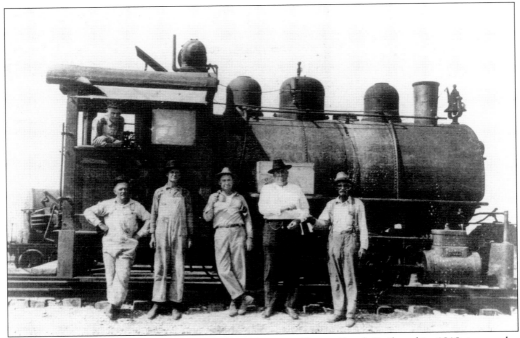

When Ross Sterling opened the 23-mile-long Dayton–Goose Creek Railroad in 1918, it was the shortest standard-gauge railroad in Texas. Built primarily to haul oil field material, it also hauled farm products, livestock, lumber, and, starting in mid-1920, passengers. In the cab of this 21-ton locomotive is Frank Sloan. Standing from left to right are W.H. "Shorty" Callam, C.C. Matthews, W.E. Wolf, W.S. Shirley, and C.H. "Dad" Jones.

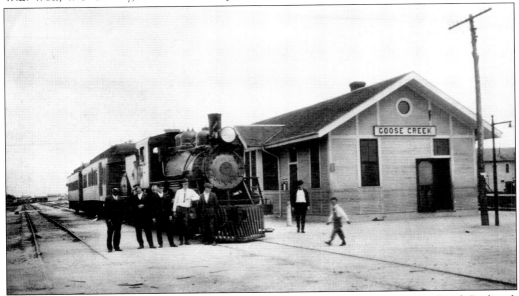

The Goose Creek depot was built on Texas Avenue in 1918 for the Dayton–Goose Creek Railroad. Two years later, the line began passenger and mail service and made two trips daily to Dayton to link with the Texas & New Orleans Railroad. Southern Pacific bought the line in 1926 and continued passenger service until about 1942. The building burned in 1949 but was repaired and continued in use until it was torn down in 1987. (Courtesy Dale Cox.)

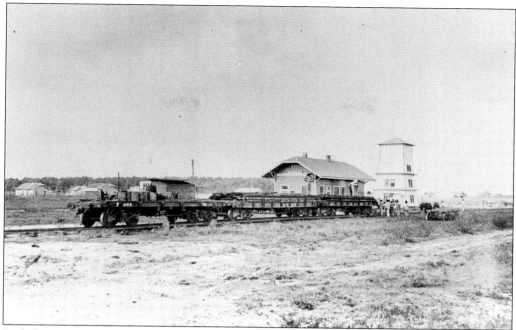

Built for commuter rail traffic between Goose Creek and Houston, tracks for the Houston North Shore Railway are being laid near the already-completed Highlands depot in the summer of 1926. The structure on the right is a wooden water tower for the occasional steam engines using the tracks. Harry K. Johnson, who built the railroad, had his office on the ground floor of the tower and lived there during construction.

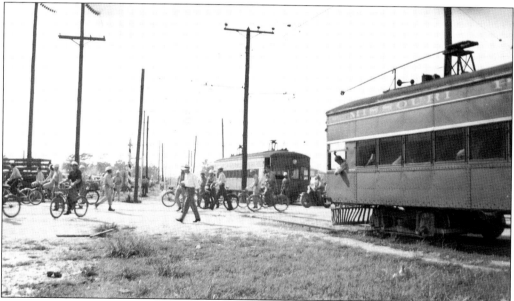

After the line was complete, Johnson sold it to Missouri Pacific, and for 35 years, the interurban played a vital role in mass transit for the Tri-Cities. In its heyday, seven cars made hourly runs between Goose Creek and Houston, with stops all along the way. This photograph shows two cars headed in opposite directions at shift change at the Humble refinery. (Courtesy Charles C. Robinson.)

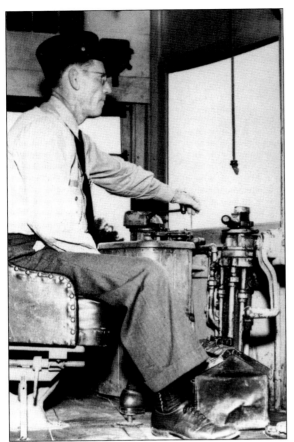

Motorman Lee Dunn made the very first run on the interurban on June 19, 1927. His left hand is on the speed controller. His foot is on the bell gong, used to communicate with the conductor at the rear of the car. The handle to the right is the air brake, and the cord is for the horn. The motorman answered the conductor's signal to stop, go forward, or back up using the bell gong. (Courtesy Missouri Pacific Railroad.)

After 21 years of operation, the last electric car made its run on September 25, 1948. The man on the left is motorman Joe G. Smith, who made the last run, and the man next to him may be Lee Cole, the Baytown station manager. The man on the far right is Timothy McElroy, who was a Missouri Pacific section supervisor. (Courtesy Paul L. DeVerter II.)

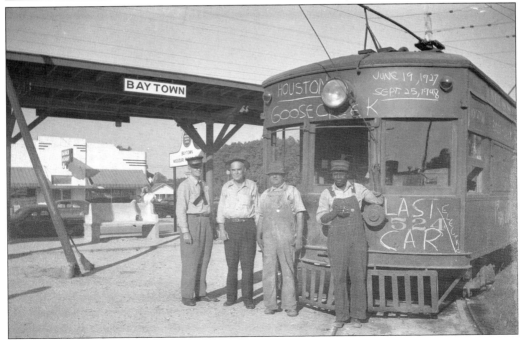

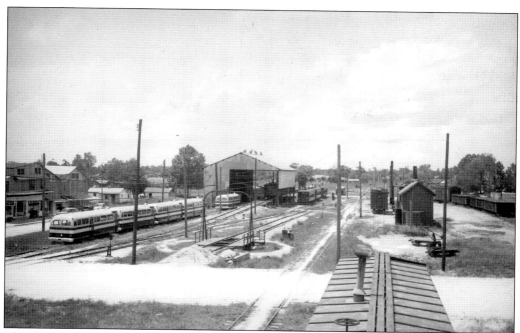

The electric interurban cars were replaced with gasoline railbuses in 1948. This photograph shows the railcar repair shop on South First Street between Humble and Republic Streets. The photograph is particularly interesting since both electric and gasoline cars are shown in the same picture.

It is a little-known fact that, besides the electric and railbus interurban cars, the Houston North Shore had steam engines as well that carried freight rather than passengers. The steam locomotives were also used for maintenance on the line and were particularly useful when electric power was interrupted. In this photograph, a steam engine is approaching the loading dock in Baytown.

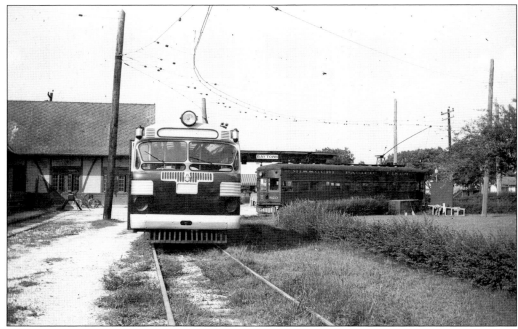

In 1948, several railbuses were purchased to replace the electric cars. They gave a smoother ride and were not subject to the occasional breakages in the 600-volt power cables. This photograph, taken in 1948 at the Baytown terminal, shows both types of cars. After a long period of reduced schedules, the interurban shut down in 1961. (Courtesy Paul L. DeVerter II.)

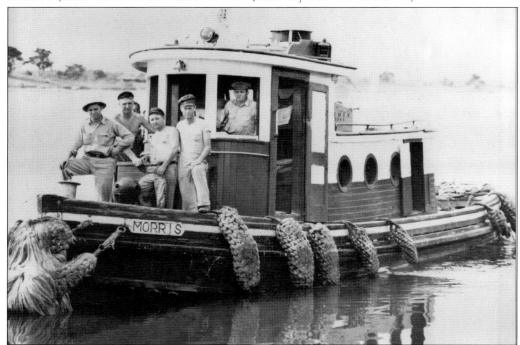

The tugboat *Morris* was one of a long line of boats built on Cedar Bayou. Built at John Kilgore's shipyard in 1930, it was 42 feet long, had a 65-horsepower engine, and displaced 11 tons. It worked the waters of Cedar Bayou and the Houston Ship Channel until it was scrapped in 1973.

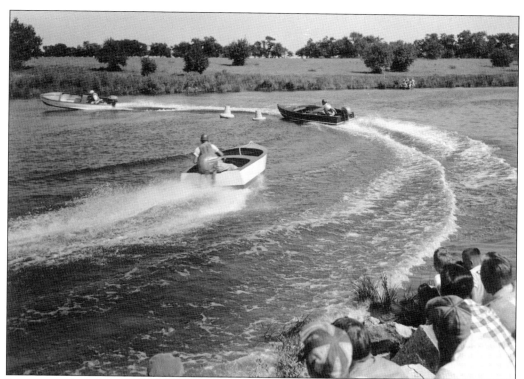

Boat racing has always been a popular sport in Baytown. In the 1850s, the San Jacinto Yacht Club held schooner races from Lynchburg to Cedar Bayou and back, but by the 1900s, increasing ship channel traffic forced the races to other venues. By the 1940s, the Baytown Boat Club held races at Burnet Bay and Cedar Bayou. There were divisions for outboard motors from one horsepower to more than 50.

From the earliest days, sailboats played an important role in transportation, commerce, and recreation. With almost 25 miles of coastline and almost impassible roads for much of the year, wind power in the 1800s was the most efficient means of getting around. Before the Civil War, the San Jacinto Yacht Club held races between Lynchburg and Cedar Bayou. The tradition continued in the 20th century with races in the bays.

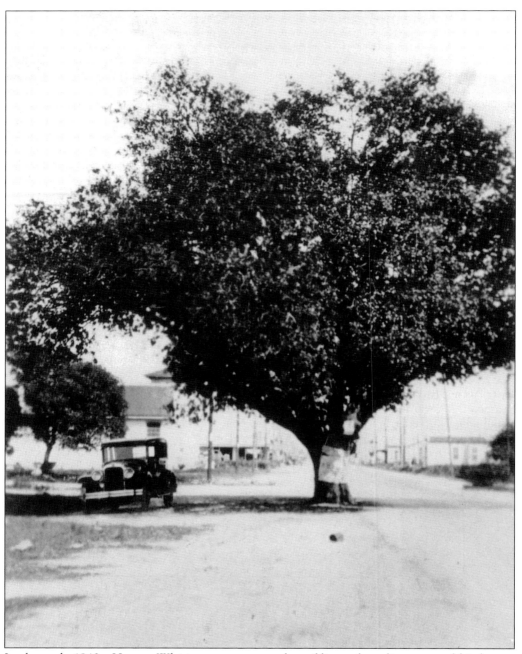

In the early 1840s, Harvey Whiting set out a number of live oak saplings around his house. Baytown's big oak tree, still standing in the middle of Texas Avenue, is almost certainly one of those trees. It originally marked the Goose Creek city limits, and when Market Street was extended to Goose Creek in 1927, the tree was slated to be cut down. But Ross Sterling, then president of Sterling Properties, directed that the road be rerouted. In 1950, the Baytown City Council voted to cut it down, but Rolland "Red" Pruett, city councilman and former owner of the land that became Goose Creek, intervened. It has been called the "hanging tree," although nobody was ever hanged there. The tree has survived disease, drought, and termites, and for many years, it served as the symbol of the city of Baytown.

Texas Avenue had undergone a resurfacing project in 1944, when gravel was spread and covered by asphalt. But within months, the roadbed failed. It was decided to lay a concrete roadbed and install water, gas, sewer, and drainage piping at the same time. In July 1945, the citizens of Goose Creek overwhelmingly approved a $600,000 bond election with $300,000 earmarked to pave 40 city blocks with concrete and 29 miles of secondary streets with asphalt topping. While the streets were torn up, another part of the project installed water and sewer piping beneath the road. Texas Avenue was torn up for weeks, but much of the original concrete from that project remains.

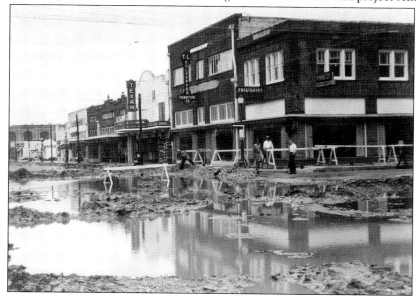

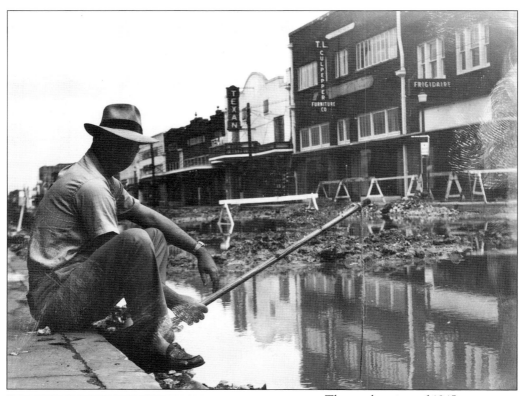

The road project of 1945 was terribly inconvenient and lasted for weeks, but four long years of war following a depression had taught the lesson of pragmatism and patience, so the citizens made the best of a bad situation.

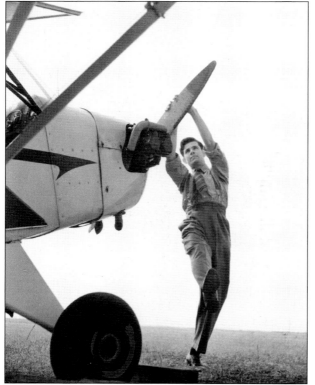

In 1931, the Goose Creek Chamber of Commerce opened the first airport in the area at the intersection of Garth Road and Cedar Bayou Lynchburg Road. Claude Eure had a Piper Cub, and Gladstone Butler started the Tri-Cities Aviation Company in 1940 with a Stinson. Lee College started a pilot program that fall, and Stanford Toups is shown "spinning the prop" of the Piper Cub in this 1940 photograph.

Five

SCHOOLS AND CHURCHES

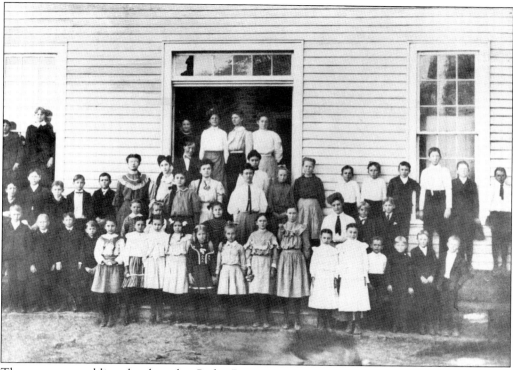

There was no public school in the Cedar Bayou community before 1876. That year, the new Texas Constitution provided for local districts, called school communities, each containing one schoolhouse. Three schools were started in the Baytown area that year: Cedar Bayou, Goose Creek, and Lynchburg. The Goose Creek School was located on the intersection of today's South and West Main Streets. It was moved in the 1880s and closed for white children in the segregated system about 1897, becoming the school for Black children. From 1876 to 1911, school in the Cedar Bayou community was held on the ground floor of the Cedar Bayou Masonic Lodge, shown here, until the brick schoolhouse was built. This picture, taken about 1908, shows children of the Casey, Pruett, Ilfrey, Fisher, Barkaloo, Haden, Lawrence, McLean, and other families in the community.

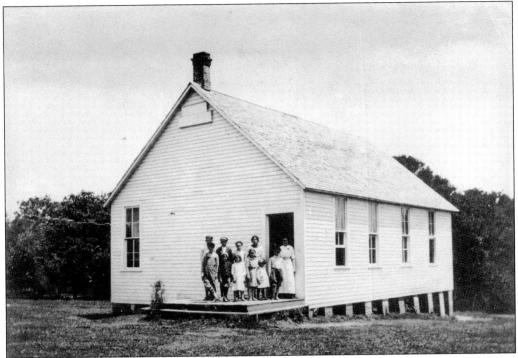

Built to educate grades one through seven, Wooster School No. 38 was erected in 1894. After consolidation with Goose Creek Independent School District in 1919, the building served in various capacities until 1980, when it was retired and later relocated to the Republic of Texas Plaza. It continues its service in education as a living history museum under the auspice of the Baytown Historical Preservation Association. (Courtesy Wybra Wooster Holland.)

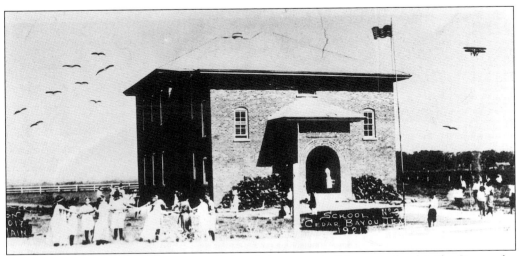

In 1911, voters in Cedar Bayou approved a bond election to build a new school. Mike Casey, who had a brickyard on Cedar Bayou just to the south, supplied the brick. There were two classrooms downstairs with a seating capacity of about 48 each and an auditorium above that could seat about 200. People remember roller skating in the auditorium. The building was torn down in 1938.

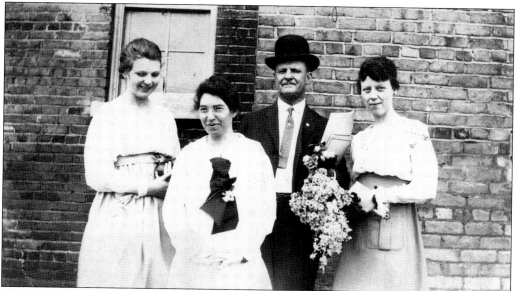

The two-story brick Cedar Bayou schoolhouse, built in 1911, was the only schoolhouse in Cedar Bayou for several years. The principal in 1918 was Plummer Stegall, wearing the derby, and the teachers were, from left to right, Gladys Malone, Ida Bond, and Ohmie Wilcox.

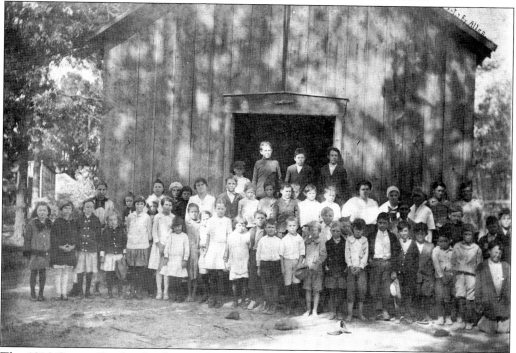

The 1916 Goose Creek school year closed with 20 students in this building. But during the summer, an oil gusher was struck, and hundreds of men came with their families. When school started in the fall, there were 60 students in Cora Lazenby's class. The enrollment had grown to 200 when a nearby oil well blew out in January 1917, spewing oil, sand, rocks, and millions of cubic feet per day of natural gas. The deafening roar and danger of explosion forced the school to permanently close.

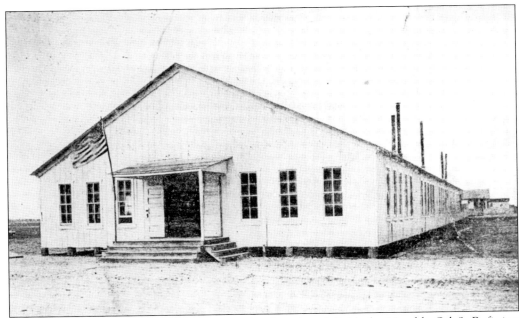

After the gasser shut down the one-room school in the oil field, the Humble Oil & Refining Company provided an unused bunkhouse in New Town as a school building that came to be known as "the Barn." Grades one through eight were taught in its six classrooms with a large open space in the center. It opened in September 1917 with seven teachers and about 250 students. When school started back up in 1918, four hundred students were enrolled, so the building was enlarged and more primary schools were established in Middle Town. When the Goose Creek Independent School District was formed in 1919, the student population was up to 619, and the trustees leased the YMCA building to use as a high school. The Barn was used as a school until 1923.

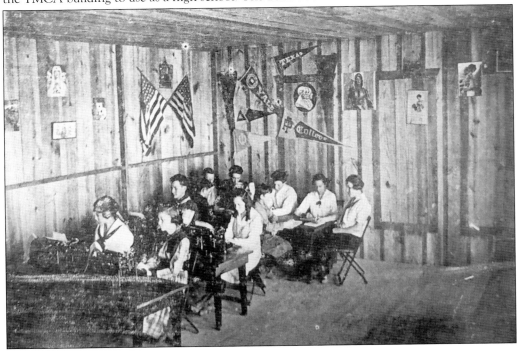

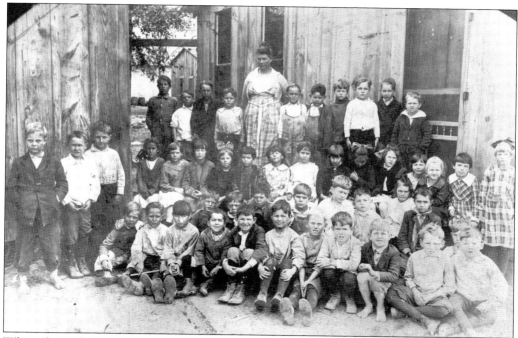

When these photographs were taken in 1919, Allie Blackwell (above) and Elsie Duke (below) taught primary grades. This building was formerly the Derrick Store, which the school district had leased and remodeled for classrooms. It was located near today's intersection of West Main Street and Lee Drive. School for Black children in the segregated district was held at Mount Rose Baptist Church the first year with Tillie Brown as the teacher. In 1920, the Anderson Grocery Store was leased and remodeled for her class. Both the church and the school were located near today's George Washington Carver Elementary School.

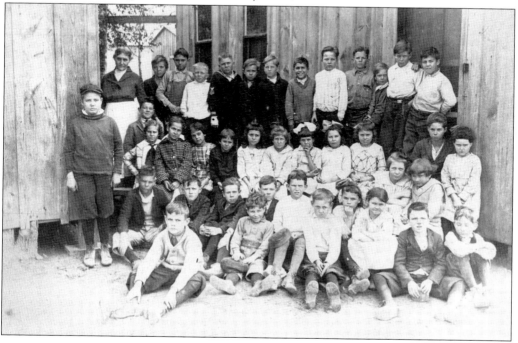

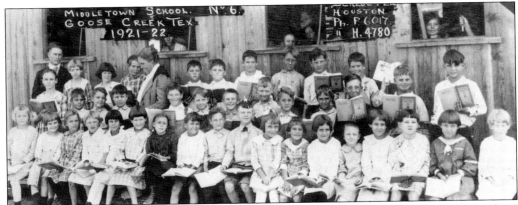

In 1919, the scholastic population at Goose Creek was at a breaking point, so the county school superintendent asked the oil companies responsible for the growth to help provide additional facilities. Gulf Production Company donated an abandoned blacksmith shop in the oil field, which was used for classrooms over the next four years. By the 1921 school year, the scholastic population of the school district numbered almost 1,000 students, and the average class size was 45. By 1922, the population was over 1,200. In 1921, Mary Roper taught Middletown School No. 6 in the blacksmith shop.

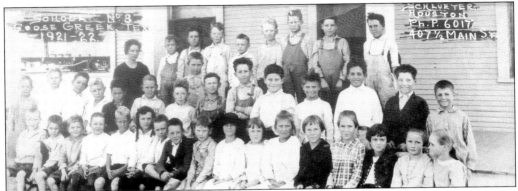

Located just east of today's George Washington Carver Elementary, this school building was erected in the 1880s. School board minutes refer to it just as the "old school house" when a toilet and plumbing were added in August 1919. This teacher's name is unknown, but teachers in this school during the 1880s and 1890s were Katie Gaillard, Stella McCracken, Annie Langford, Mamie Blackshear, and Clement Appleyard. From 1897 to about 1905, it was the Goose Creek Colored School.

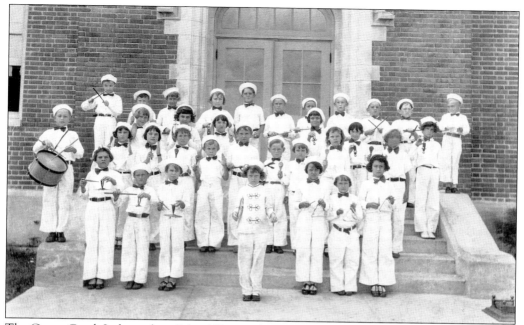

The Goose Creek Independent School District hired Esther Krenick as a music teacher in 1928. Besides forming the Rhythm Band at Ashbel Smith and Alamo Elementary Schools, shown in this 1930 photograph, she played piano for the silent movies at the Oiler Theater and accompanied many local talents on the Tri-Cities broadcasts on radio station KXYZ.

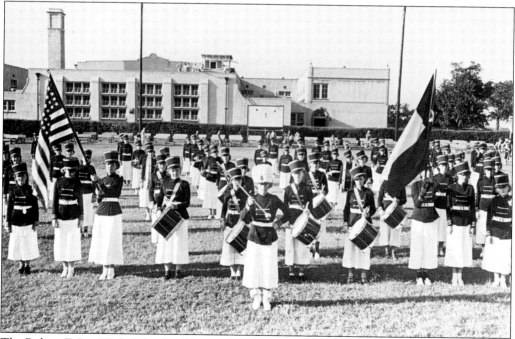

The Robert E. Lee High School girls' pep squad, under the leadership of Corrie Hester and Myrtis Smith, was formed in 1926. Their official uniforms, worn only on game days, were red dresses and white coats. They learned new songs and cheers and performed at halftime of football games. In 1934, they got new uniforms and were renamed the Maroon Brigadiers.

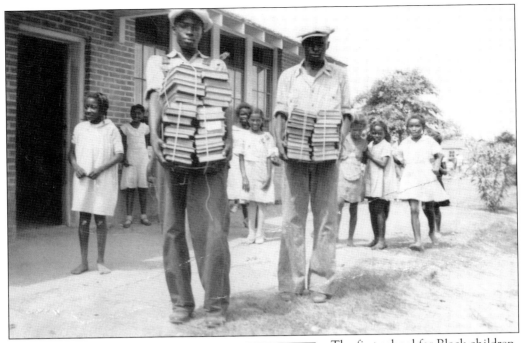

The first school for Black children in the Goose Creek Independent School District opened in 1919 at Mount Rose Baptist Church, which at the time was located near today's George Washington Carver Elementary School. The following year, the school board leased the Anderson Grocery Store as a classroom. The brick building shown here was erected in 1924, and this photograph from 1933 shows a delivery of books to the library. (Courtesy Harris County Public Library.)

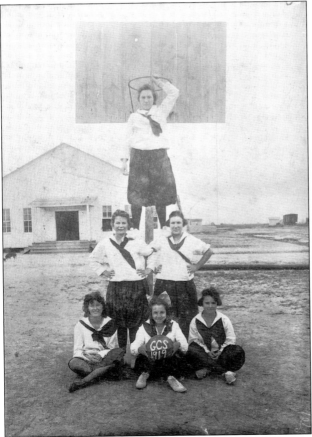

The 1919 girls' basketball team ended a great season with a 19-1 victory over Humble at the county tournament. The team members were, from left to right, (first row) Ruth Grandstaff, Gladys King, and Virginia Ward; (second row) Louise Grow and Eunice Early; (third row) Francis Ayrhart, who was voted Most Athletic Girl. The coach, Ola Raney, is not pictured.

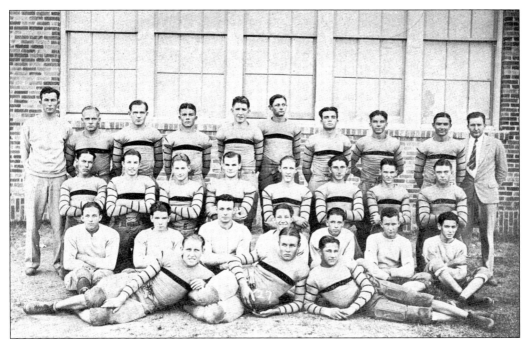

In 1927, the last year of Goose Creek High School, the Ganders shown in this photograph posted a 7-2 season, outscoring their opponents 157-27 and holding all but two opponents scoreless. When the new stadium replacing Pruett Park was built in 1930, it was named Elms Field in honor of coach Roy Elms, shown in the back row on the left. (Courtesy Roy Elms.)

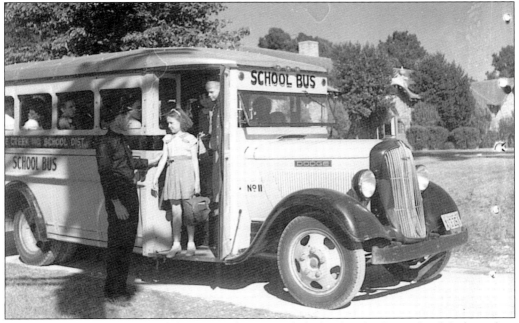

When the 1936 spring term ended, 4,025 students attended school in the Goose Creek Independent School District. But by the time school started in the fall, the district had annexed Highlands, and then 5,061 students needed a way to get to school, so the district had to purchase six more buses. This photograph, taken that year, shows students riding bus no. 11.

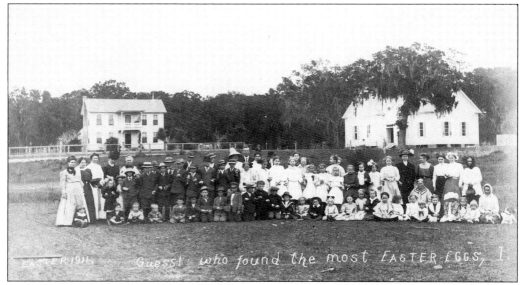

Cedar Bayou Methodist Church was founded in 1844 near Midway. The congregation purchased 10 acres on Cedar Bayou in 1847 and built a parsonage there that was converted to use as a chapel after the church on the bay was destroyed in the 1854 hurricane. A new church was built near the parsonage in 1858 and used until 1886, when Alexander's Chapel was constructed. This photograph shows Alexander's Chapel on Easter Sunday 1911. The two-story parsonage is the building at left, and Alexander's Chapel is still standing on the church property. (Courtesy Shirley Damron.)

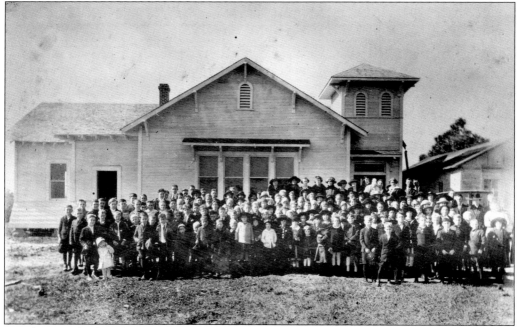

St. John's Methodist Church was organized in 1913 as a mission church of Cedar Bayou Methodist to serve people in the Goose Creek oil field. The first meetings were held in tents, and when an oil well blew out nearby in March 1917, C.T. Rucker donated a small building on the corner of today's Bolster and Thibodeaux Streets in Middle Town. The building in this photograph was erected in 1921 on the same lot. (Courtesy St. John's Methodist Church.)

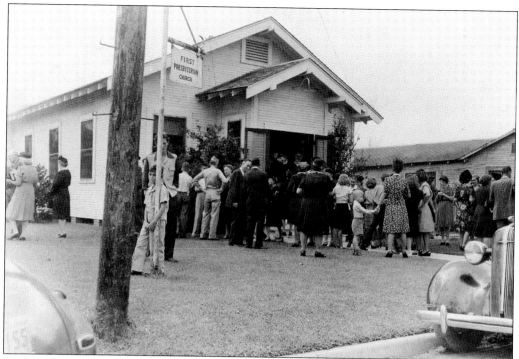

First Presbyterian Church was organized by Rev W.G. Huie in November 1922. The congregation met at the Odd Fellows Hall until the church was completed on the corner of First Street and Defee Avenue the following May. When the new brick church was built on Market Street in 1948, the old church was moved and served for many years as a fellowship hall and classroom. (Courtesy Faith Presbyterian Church.)

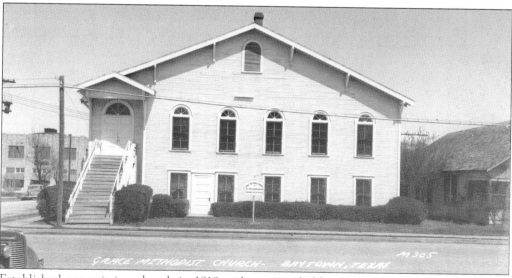

Established as a mission church in 1919 with services held in the YMCA building in Goose Creek, Grace Methodist Church was organized on January 7, 1921. The following year, the congregation built this church on West Pearce Avenue between Jones and Gaillard Streets. In 1948, it moved into a new building on Pruett Street that was the first air-conditioned church in Baytown. (Courtesy Texas State Library and Archives Commission.)

First Baptist Church of Goose Creek was organized by John Wesley Anderson in February 1918. After meeting for several months in the Dixie Theater, the congregation built a new church on East Texas Avenue. By 1928, they had outgrown that building and erected this church on West Pearce Street at Jones Street. In 1948, they changed the name to Memorial Baptist and moved into their present building on West Sterling Street in 1955. (Courtesy Texas State Library.)

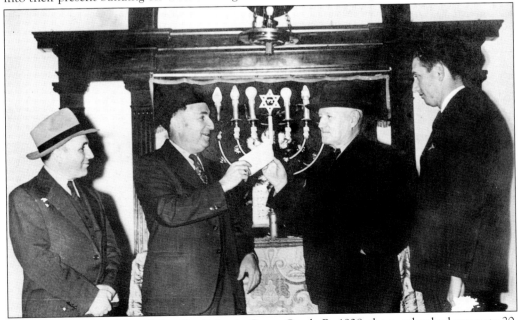

In 1920, there were 12 Jewish families living in Goose Creek. By 1928, the number had grown to 20, and the congregation incorporated as K'Nesseth Israel. On December 21, 1943, the congregation held a "mortgage burning" celebration for the synagogue, which was built in 1931 and is a recorded Texas historic landmark. Participants are, from left to right, Sam Davis, Mose Sumner, Rabbi Ben Danziger, and Joseph Guberman. (Courtesy K'Nesseth Israel.)

Mount Rose Baptist Church was organized in 1919 in Middle Town. Originally located east of its current location, the congregation erected this building in 1928. Besides providing religious services, the church served as a community building and provided classroom space for the schoolchildren in the neighborhood. The photograph shows members of the senior choir in the late 1940s. (Courtesy John Robinson.)

Central Baptist Church was organized in 1921 in an old theater. The congregation planned a new building on the same lot but sold it to the City of Pelly for the new city hall. The church erected the sanctuary shown here at the intersection of what are now King Street and Bowie Street in Pelly in 1928. A new brick sanctuary was erected in 1954 where the church still meets. (Courtesy Texas State Library and Archives Commission.)

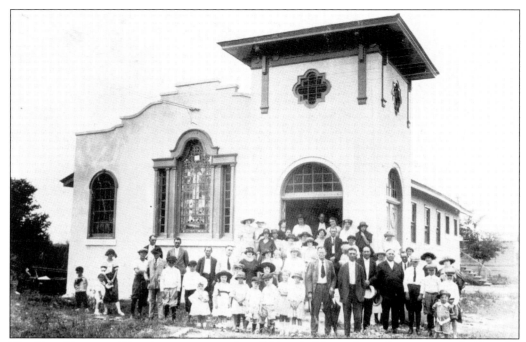

The First Christian Church was organized in 1920 with 33 members. Services were held at the Oiler Theater until the building shown here was erected on Texas Avenue at Whiting Street in 1921. The first preacher was Rev. Albert T. Fitts, and by 1925, the church had grown to 200 members. It sold the property and moved to a new location in 1939, and this building was torn down to construct a service station. (Courtesy Reed Woodcox.)

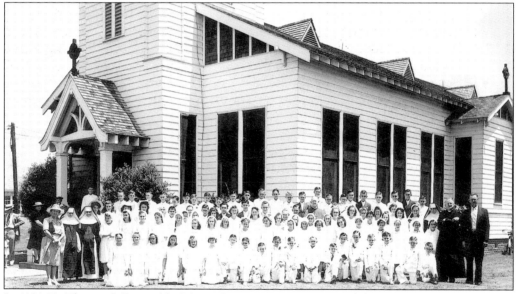

In 1921, Fr. Thomas J. Finn of St. Mary's Seminary in La Porte said the first mass in old Baytown at the Humble Oil recreation hall. Mass was also said in the Mexican recreation hall and in private homes. The Catholic population of the entire district then was 35 families. Emily J. Leger, who also dedicated the Leger subdivision, donated land where St. Joseph Catholic Church was built in 1928. (Courtesy St. Joseph Catholic Church.)

BUSINESSES

Town of Louisville.

THE undersigned having laid off the scite of a town to be called by the above name adjacent to their cotton gin house and store, half way between Lynchburg and New Washington, will offer for sale at Auction on the 4th July next on the premises, a number of building Lots. The situation needs no recommendation to those acquainted with its advantages. The main channel of the San Jacinto running close to the shore affords the most convenient landing and facilities for repairing or constructing vessels; plenty of good water and building materials immediately in the vicinity, and being the only good landing on that part of the river, together with the rapid improvements in the neighboring back country afford an assurance that it will soon become a place of importance.

N. B. For sale as above a general assortment of DRY GOODS, Groceries, Hardware, Harness, ready made Clothing &c. A *Map* of the town to be seen at the store of Doswell & Adams, Houston. GEO. W. & WM. H. SCOTT.

Louisville, June 18th, 1838. 3s-tf

After the death of William Scott at his home, called Point Pleasant, in 1837, his sons laid out a town there and named it Louisville. The town had at least 12 blocks where A.L. Crossman had a store, Dr. David Drysdale had a medical practice, and Walter Dyer built a shipyard with dry dock facilities for steamboats. In 1843, the precinct voting place was at Louisville. The first church in Harris County outside of Houston was established there as well. In 1844, Margaret Houston wrote a letter to her husband, Sam Houston, about attending the Methodist church with L.S. Friend, the preacher. Louisville did not thrive, and a devastating hurricane hit the area in 1854, destroying everything left of the place. In the aftermath of the flood, the church was rebuilt on Cedar Bayou on land that had been purchased in 1847. The map referred to in this June 30, 1838, *Houston Telegraph* article has not been found.

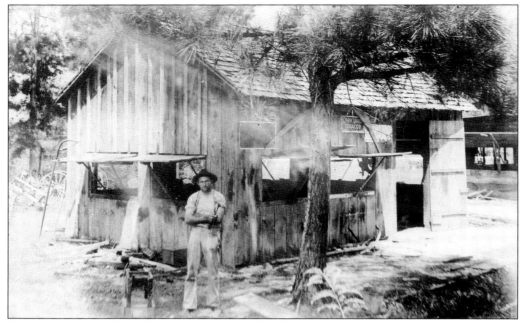

This photograph of James Nicholas Gourlay and his blacksmith shop, located near the intersection of today's State Highway 146 and McKinney Avenue, was taken about 1907. He would later become assistant postmaster and justice of the peace in Chambers County, and when he died, his dog, Rex, quit eating and starved to death 14 days later. (Courtesy Shirley Damron.)

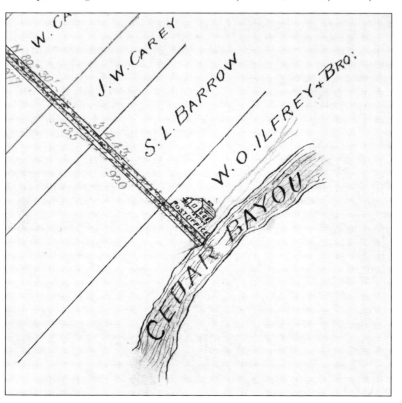

In 1860, Seth Cary established the town of Shearn on Cedar Bayou, and the following year, Harris County commissioners built a road from Goose Creek to Shearn. Charles F. Ilfrey built a store on the water's edge where he also ran a ferry. In 1870, the Cedar Bayou Post Office opened in Ilfrey's store, and the town of Shearn came to be known as Cedar Bayou. This survey was made by Harris County in 1902. (Harris County Archives.)

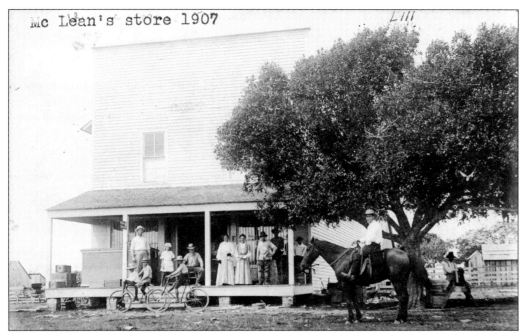

Some time before 1886, Joseph Lawrence built his store and residence across the road from Ilfrey. Like Ilfrey's store, Lawrence's store became a community center where elections, tax assessments, and other public meetings and activities were held. He died in 1897, but his family kept the store going. (Courtesy Denise Reineke Fischer.)

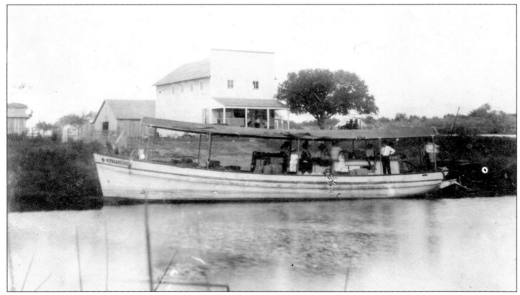

Joseph Lawrence's widow sold the store and house to Thomas McLean in 1903, and McLean's store continued as a Cedar Bayou landmark for many years. McLean closed the store about 1928. This 1907 photograph shows Thomas McLean's store and Matt George's boat, *Mayflower*. (Courtesy Denise Reineke Fischer.)

Cedar Bayou Road, laid out in 1861, ended at the ferry landing, which back in the day looked more like a boat ramp. The building on pilings across the road from McLean's store is Ed Ilfrey's warehouse. Ilfrey's boat, *Virginia*, is docked next to the warehouse, and *Mayflower* is docked at McLean's landing. (Courtesy Denise Reineke Fischer.)

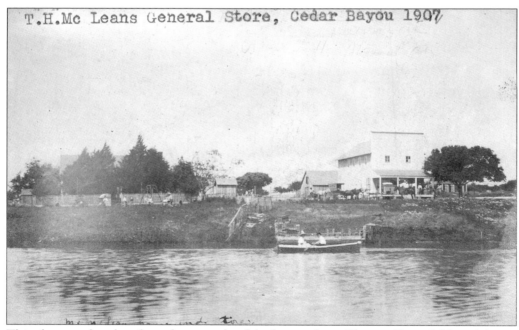

T.H.Mc Leans General Store, Cedar Bayou 1907

This photograph, taken from the east side of the bayou, shows Thomas Henry McLean's house surrounded by the picket fence with neighborhood children playing on the grounds. His store and his dock can be seen just to the right behind the rowboat. The store was torn down about 1932. (Courtesy Denise Reineke Fischer.)

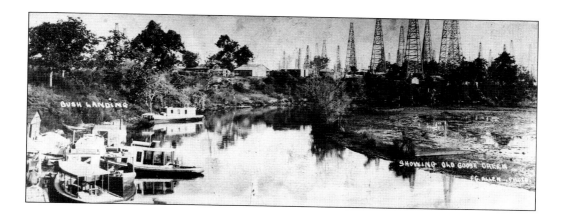

Busch Landing had been an important port since the mid-19th century. It was the site of Thomas Chubb's Confederate shipyard, where several boats were repaired and at least one was built. It was the site of Elizabeth Page's brickyard in the 1870s, and after Henry Busch bought the 20-acre tract from her in 1895, he established a trading post. When oil drilling started in the early 1900s, he expanded the facilities with a dock and stores. The Mitchell Barge Line had a warehouse and shipping center there, and a residential community called Gulf Hill sprang up and lasted into the 1970s. Over the years, the high bluff overlooking Goose Creek stream was excavated for the sand, and as residents left and died, the community faded away. Today, there is nothing left but a few oil wells. (Above, courtesy Jake Daniel; below, courtesy Denise Reineke Fischer.)

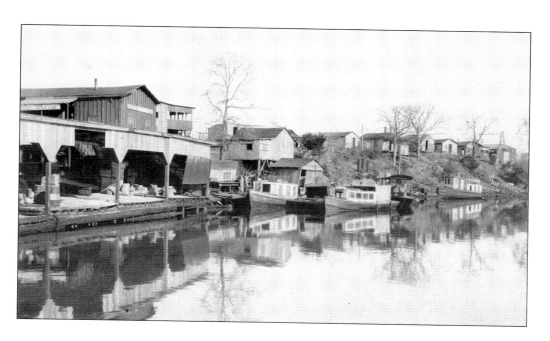

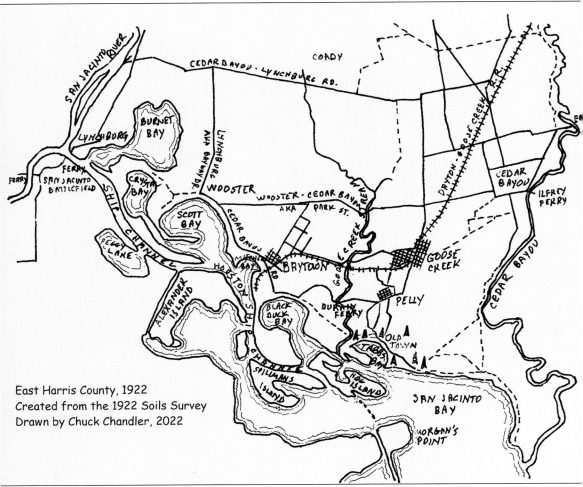

East Harris County, 1922
Created from the 1922 Soils Survey
Drawn by Chuck Chandler, 2022

This map shows the Tri-Cities as they were in 1922. Goose Creek had incorporated in January 1919, and Pelly incorporated that December. Baytown never incorporated, preferring to exist as a company town of Humble Oil & Refining Company. Cedar Bayou began as the town of Shearn, laid out by Seth Cary near the Methodist church in 1858. The unincorporated community of Wooster got its start in 1895, when Quincy Adams Wooster moved from his home in Iowa. Not shown on the map is Elena, later named Highlands, north of Lynchburg. Also not shown are the future towns of Coady and McNair, located just east of Highlands. Elena was created by the San Jacinto Rice Company, and Coady and McNair began as farming communities on the Houston North Shore Railway.

In 1916, the Lone Star Meat Market in Old Town was located across the road from the Lone Star Restaurant. When the Rucker No. 1 oil well blew out in December, they moved to Middle Town. In this photograph, the owner, Sam Ashwood, dressed in black, is on the right. The sign says the store sold Wamba coffee. It must have been a popular brand because R.C. Stephenson carried it, too.

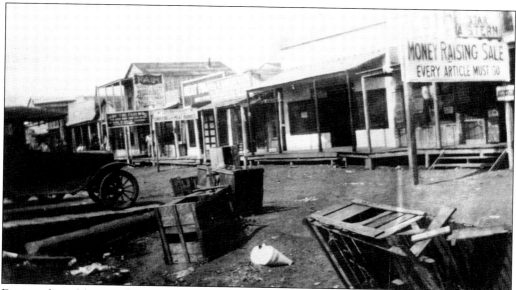

During the oil boom, the area's population exploded with transient oil field workers, but land owners did not sell property for residential or commercial use, holding out in the hope of leasing for oil drilling. As shown in this photograph, taken on West Main Street in Middle Town in the early 1920s, merchants initially chose to not erect permanent places of business, and people seemed to care little for improvements in the community.

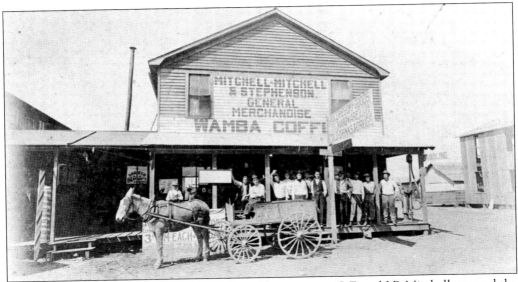

In 1917, Rupert C. Stephenson, in the vest, and his partners, G.F. and J.P. Mitchell, opened the first grocery in Middle Town. The store sold groceries, dry goods, ice cream, gasoline, hardware, soda water, and ready-made cigarettes, and it rented rooms and sold tickets for the express to Houston. By 1928, Stephenson had bought out both partners, and he stayed in business until the mid-1960s. The building still stands on West Main Street.

L. Victor Cook opened the first electric shop in Goose Creek in 1917 on the south side of Texas Avenue just west of Pruett Street. By 1925, Cook Electric had wired over 1,000 homes and all the commercial buildings in the area. I.M. "Deacon" Jones is on the right. At far left, in the suit, is L.V. Cook. The other men might be A.O. Reeves and C.R. Pope, who were electricians living in the same boardinghouse with Cook.

New Town got its first store in February 1917. The Goose Creek Mercantile Company was incorporated by C.E. and J.T. Goolsbee of Warren, Texas, and A.L. Clarke of Goose Creek with a capital stock of $10,000. It was the first business to open on West Main Street, located across the street from today's Robey Funeral Home. West Main Street was renamed West Sterling Street in 1948.

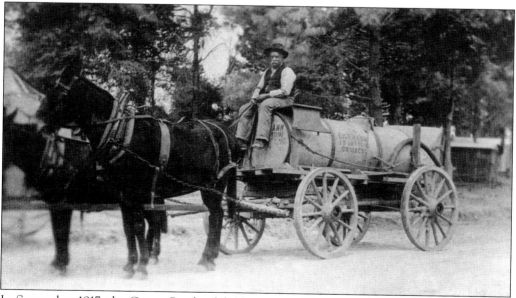

In September 1917, the Goose Creek oil field was served by an artesian well on the American Production Company property, and it planned to shut the water off when it resumed drilling operations. Water from the well was hauled to homes in barrels, but there were also many shallow wells that contributed to a typhoid epidemic. This photograph, made in 1918, shows the water wagon owned by Ed Eisemann. Water sold for 25¢ a barrel.

In April 1917, a group of investors started the Guaranty State Bank, located in Middle Town, and two months later, deposits totaled $80,000. In May 1919, banker J.C. Stribling purchased two lots on the northeast corner of Texas Avenue and Ashbel Street and erected the building shown in this photograph. At the time, it was the only bank in town.

Thomas Loomis built his hardware store on West Pearce Avenue between Commerce and Ashbel Streets some time before 1921. This photograph, looking west, shows the two-story brick building erected by William L. Pearce where his brothers, Oscar, Edgar, and L.M., were living in 1920. That building was torn down by 1923. Pearce Avenue was named for the brothers, who formed Texas Iron Works in 1917.

This photograph of Texas Avenue looking east from Ashbel Street was taken in 1920. John Dee Joiner, general manager of the Joiner Mercantile Company across the street, was also the president of Guaranty State Bank. The bank had moved from Old Town to New Town Goose Creek in 1919 and had just been recently remodeled. The Goose Creek Post Office was next to the bank, and the obstruction in the intersection was officially called a dummy policeman. Its purpose was to prevent drivers from rounding corners.

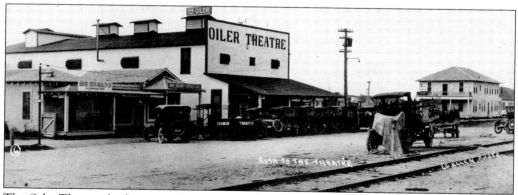

The Oiler Theatre, built in 1919 by the Goose Creek Amusement Company, stood on the corner of Defee Street and Commerce Street. It burned down in 1921 but reopened that September with the movie *Redemption*. The Oiler closed after the Texan Theater opened in 1926. The building was used by several churches and later by Culpepper's furniture company as a warehouse. It burned down in 1974. This photograph shows the original building.

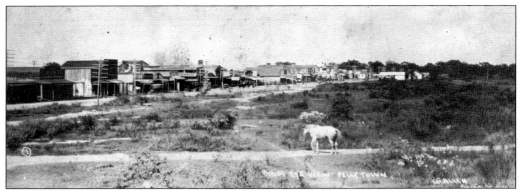

This view of Pelly looking toward the east, taken in 1919, shows West Main Street with the places of business on the north side of the road. The south side of the road, owned by L.W. Jones, would be developed as the Jones Addition in 1921. The white horse is walking north on the Oil Field Road, today called Lee Drive.

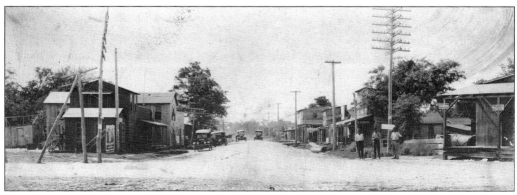

This photograph, taken in 1920, shows the Oil Field Road looking south from Pelly's Main Street. The marquee shows that *Who's Your Servant* was playing at the Cozy Theater. Due to the tremendous population growth, the Derrick store on the right side of the road was used for a classroom in 1919. The Derrick store building was later used by the Pelly News Stand. (Courtesy Jake Daniel.)

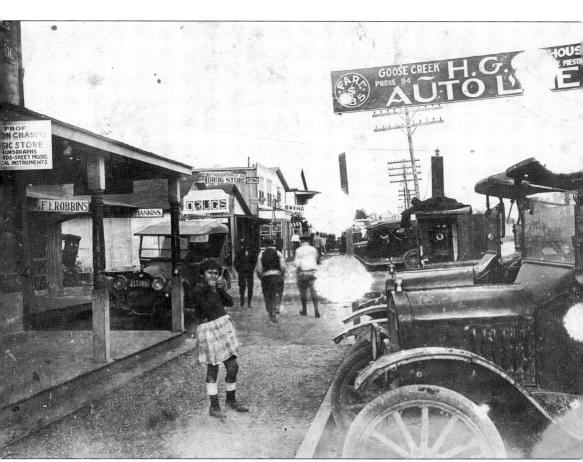

Prof. Leon Chassy's music store was like many early businesses that left no trace after they closed. But in this 1921 photograph in Pelly, Dr. Frank L. Robbins had begun his practice, and he would continue to serve Baytown until his death in 1953. Dr. Lawson A. Hankins would later start the Baytown Hospital and serve as its president until 1961. Garrett Herring worked at Isadore Wiesenthal's drugstore and would later have his own business on Texas Avenue. Wiesenthal's store was on the corner of West Main Street and Edna Street at the site of the later Leggett's Drug Store. The Cozy Theater was in Stephenson's store and later moved next door. The photograph also shows Pelly's first public telephone, and one could catch a ride to Houston on the Houston–Goose Creek Auto Line, which started operations in 1917. R.L. "Shorty" Curd had a fleet of jitneys managed by J.P. "Blacky" Newcome in Middle Town and L.D. "Blondy" Pierson in New Town.

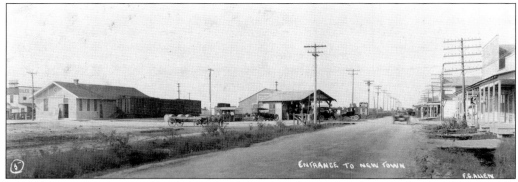

In 1917, Main Street was called Goose Creek Street and was just a dirt road leading from Middle Town to New Town. There was a Humble filling station where Rooster's Café is located today. The Goose Creek Feed Store on the far side of the filling station is still in business today as Jack's Hardware, and the Oiler Theater is visible behind the station on Commerce Street. (Courtesy Jake Daniel.)

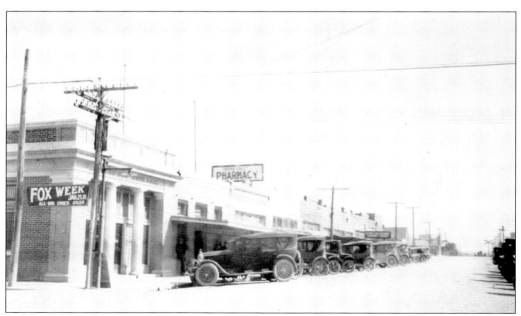

Guaranty State Bank was reorganized as State Guaranty Bank in April 1924. Along with the new name, the building was remodeled, with columns added to the facade. This photograph, taken in 1925, shows the Goose Creek Post Office next door and the Goose Creek Pharmacy one door farther down. In 1926, it was reorganized as Security State Bank of Goose Creek.

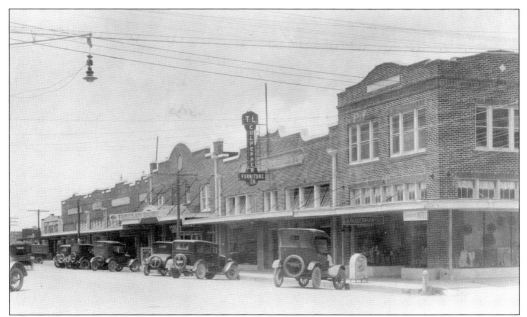

The first brick structure west of Ashbel Street on Texas Avenue was the Guberman Building, constructed in 1920 on the corner of Texas Avenue and Ashbel Street. Joseph Guberman ran his dry goods store on the first floor, and the second story was the Guberman Hotel and, later, the Goose Creek Hospital. When this photograph was taken in 1927, the Culpepper & Echols Building was still a single-story structure, and the Texan Theater was playing *That's My Daddy*.

The Union Racket Store, located on North Main Street between Texas Avenue and Defee Street, was the first five-and-dime store in Goose Creek. Its 1921 advertisement in the *Goose Creek Gasser* said it was a general variety store, carrying screen, wire, nails, garden tools, fishing tackle, and "hundreds of other things." A Mrs. S.W. Clinton was proprietress. Lillian Rice (left) and Mrs. Clinton (right) are shown standing behind the counter.

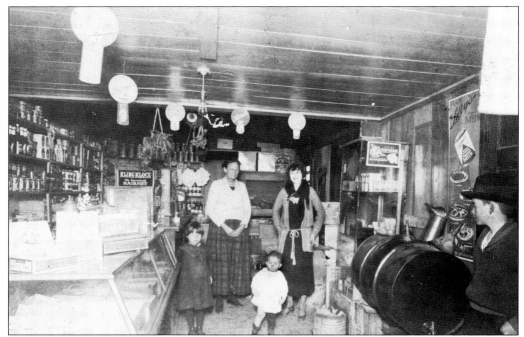

Baxter and Lucy Littlefield came to Pelly in 1920, when he went to work in the oil field. Lucy opened a small grocery store in 1923 and for 20 years served customers in this building. Baxter Littlefield's grandmother is on the left, and his wife, Lucy, is on the right. In front, the girl on the left is unidentified, and Baxter Littlefield Jr. is on the right. They built a new store at the same location in 1943 and retired in 1966.

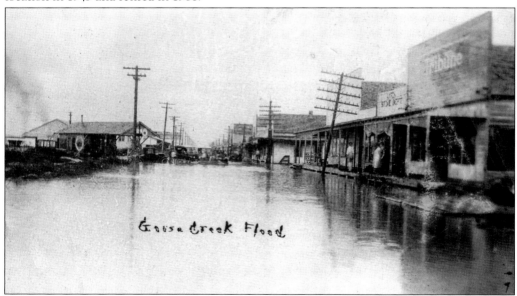

This 1925 photograph looking up North Main Street shows the *Semi-Weekly Tribune* office on the right. The newspaper started out as the *Goose Creek Gasser* in 1917 and has been in continual publication, albeit under different names, ever since. In 1931, it became the *Tri-Cities Sun*, the *Daily Sun* in 1933, and after consolidation of the Tri-Cities, it was renamed the *Baytown Sun*. (Courtesy Kay Hester.)

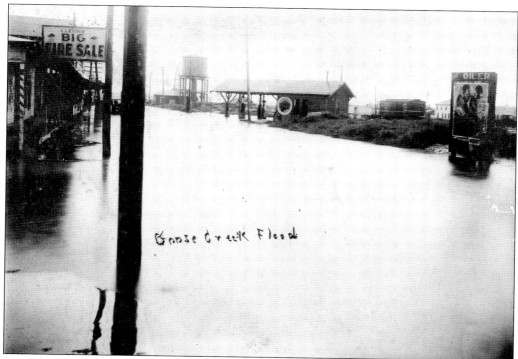

The intersection of Texas Avenue and North Main Street has always been prone to flooding. This photograph looking south down Main Street shows the 50,000-gallon concrete water tower that was built in 1918. The following photographs were taken from the top of that tower. The Humble filling station on the intersection with Texas Avenue is where Rooster's Steakhouse stands today. (Courtesy Kay Hester.)

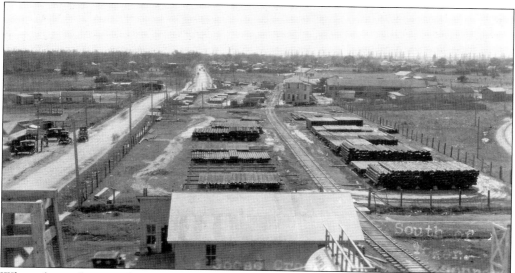

When these photographs were taken in the early 1920s, the Dayton–Goose Creek Railroad delivered oil field supplies to the Humble Oil & Refinery Company's pipe yard, where they were taken to the Goose Creek oil field down South Main Street. The Robertson-McDonald sawmill was just to the south. Farther down South Main Street was the city of Pelly, a random collection of houses still referred to as Middle Town. (Courtesy Denise Reineke Fischer.)

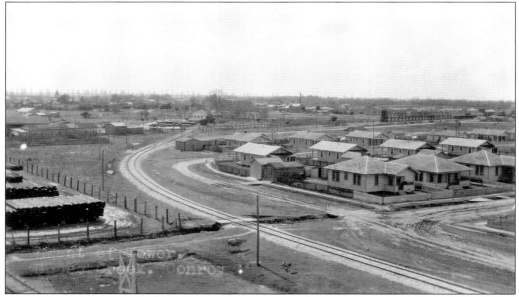

A little farther west stands the company housing for Gulf Production Company on Gulf Street. Humble Oil & Refining Company's housing was on Humble Street. The white building at the end of the rail spur was Goose Creek School No. 8. It closed when Goose Creek Ward School, later named C. Anson Jones, opened in 1923. To its right is Goose Creek High School, later named Horace Mann Junior High. (Courtesy Denise Reineke Fischer.)

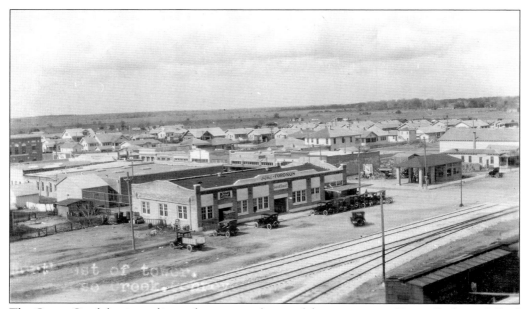

The Goose Creek business district lies just northwest of the water tower. Henry Cathriner's Ford dealership was the first brick building erected on Texas Avenue. He gained local notoriety in 1927 when his shop built two one-ton Ford trucks from the ground up using parts in stock. Price Pruett's garage was across the street, and development in the city only extended north to West Sterling Avenue. (Courtesy Denise Reineke Fischer.)

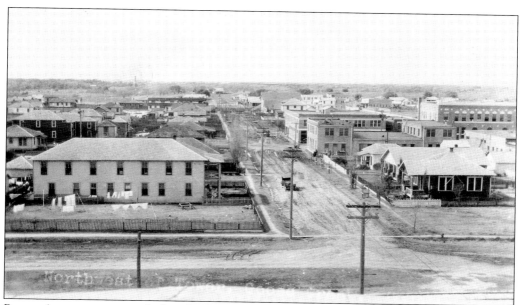

Pearce Avenue was named after the four Pearce brothers who founded Texas Iron Works and lived on the street, which would not be paved with oyster shell until later. Price Pruett's house can be seen at the far end of the street. The first intersection is South Ashbel Street, where Carl Dittman's brick building was under construction. His Baltimore Hotel, on the other side of Ashbel Street, was already completed. (Courtesy Denise Reineke Fischer.)

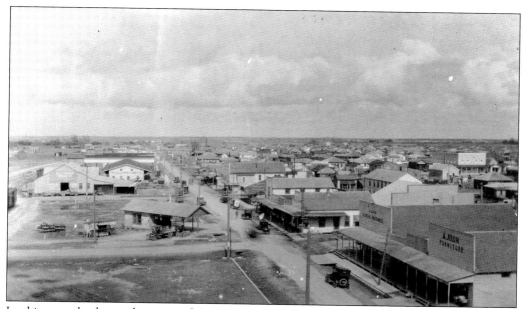

Looking north, the road continued to Cedar Bayou. In 1926, Abe Aron sold his general store to Morris Wilkenfeld, who erected a brick furniture store on the same property in 1935 and stayed in business until 2006. The Hobson Grain Company building is still standing, today known as Jack's Hardware. The filling station is on Texas Avenue, where Rooster's Steakhouse stands today. (Courtesy Denise Reineke Fischer.)

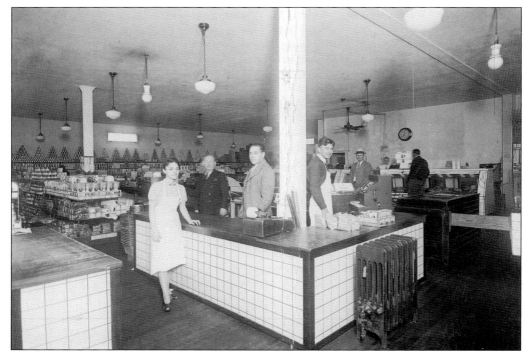

In 1923, Pincus Goldfield came to Goose Creek with his family from his native Russia and opened a grocery store on North Main Street. By 1948, he had two grocery stores, which were run by his sons, Max and Babe. This photograph shows the store on North Main Street, across from his original store. From left to right are Rosa Katz, Pincus Goldfield, Ike Lerner, and cashier Bill Reineke. (Courtesy Denise Reineke Fischer.)

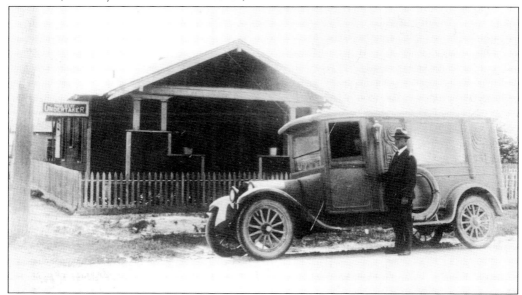

Paul U. Lee and his wife, Zenobia, moved to Goose Creek in 1923 and opened the Paul U. Lee funeral home in a rented house on West Sterling Street. For many years, it was the only funeral home in east Harris County, and when Lee died in 1963, it was the second-oldest business in Baytown under the same name and management.

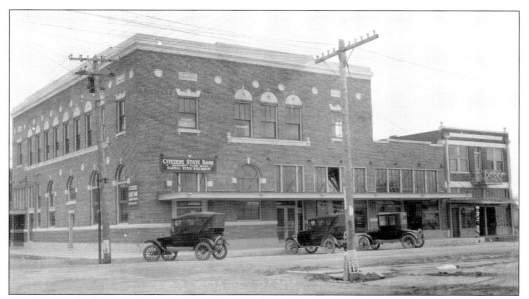

The Pruett Building was erected in 1923 on the corner of Texas Avenue and Ashbel Street. Citizens State Bank was a tenant, and the Goose Creek City Council met on the second floor until the Municipal Building was constructed in 1928. In later years, it housed Max Altman's Men's Wear and Julia's Furniture until it was torn down in 2008. Today, the Town Square Park covers the entire block. (Courtesy Denise Reineke Fischer.)

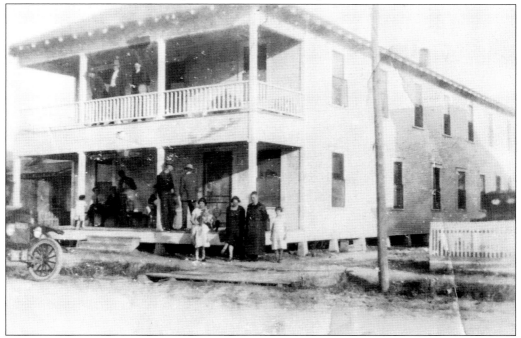

In 1923, Louie Reidland used the $30,000 he made farming rice to build the Reidland Hotel on Harbor Street in old Baytown. The hotel was on the same block with Brunson's store, Tyree Hotel, Moskowiz's Grand Leader, Wilkenfeld's furniture, and several other businesses. This photograph shows members of the Reidland family at the hotel shortly after it opened. The proprietor, Lewis Edward Reidland, is standing on the balcony in the middle (Courtesy Mike Sheets.)

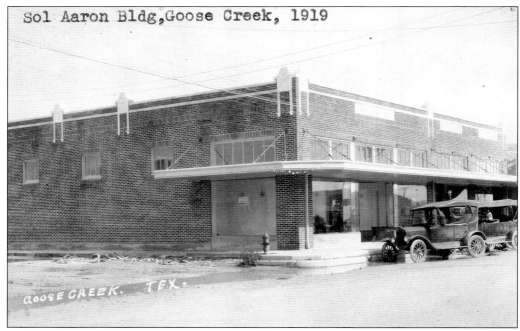

Sol Aaron Bldg, Goose Creek, 1919

GOOSE CREEK. TEX.

In 1924, Sol Aron built his Grand Leader, a popular dry goods store. Next door in the same building was the Grand Leader Barbershop. Aron sold his business in 1933, and William M. Lewis owned the barbershop from 1939 until 1945. Tommie Scarborough ran his pharmacy in the building from 1940 until 1971. Today, the building houses Legna Social Events. (Courtesy Denise Reineke Fischer.)

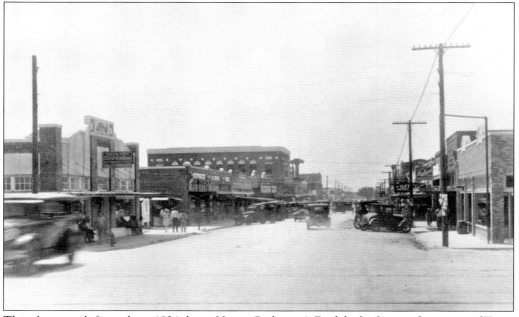

This photograph from about 1924 shows Henry Cathriner's Ford dealership on the corner of Texas Avenue and Commerce Street. Farther down the block is Herring's Drug Store, and the two-story building on the corner of the next block is Citizens State Bank. The Texas Avenue oak tree can be seen at the end of the street.

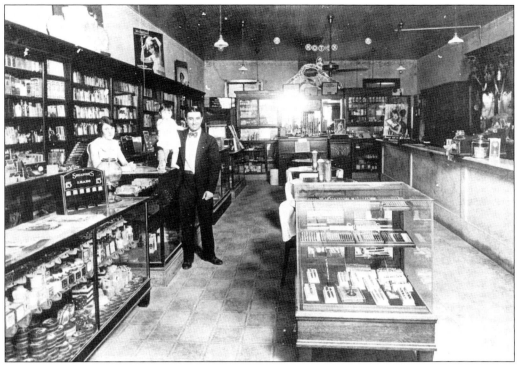

Nami Katribe's pharmacy was located at 3401 Market Street in old Baytown. It stayed in business until 1940, when the Baytown Finance Company opened on the first floor, and over the years, the building housed doctor's offices on the second floor. Nami Katribe also had his law office in the building for many years. In this picture are, from left to right, Neppie, Wanda, and Nami Katribe.

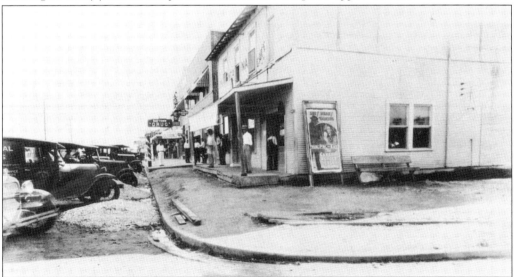

In 1923, Emma Bolan moved to Baytown from her home in Montana and purchased one acre on Harbor Street where she built a café and hotel. In 1933, she tore down both buildings and erected the Montana Café, with the Venetian Room, Baytown's first night club, on the first floor. Then she built the two-story brick Bolan Hotel next door. This mid-1929 photograph was taken when *The Canary Murder Case* was playing at the Arcadia Theater.

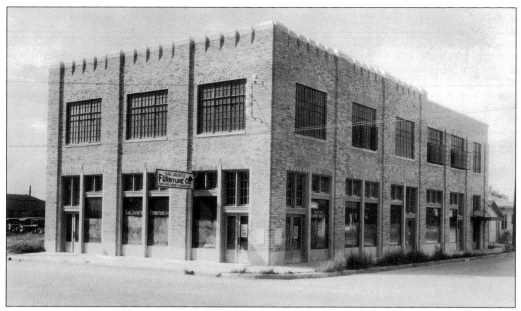

The Odd Fellows Building, on the corner of Texas Avenue and Jones Street, was constructed in 1927. The fraternal organization met upstairs, and the first floor was occupied over the years by San Jacinto Furniture Company, Tri-City Bowling Alley, Seeger Bakery, San Jacinto Buffet, and Tri-City Tire Supply. In 1931, San Jacinto Furniture Company was taken over by Culpepper's Furniture. Today, it is home to the Baytown Business Center.

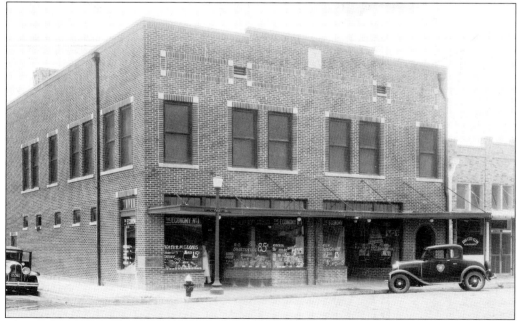

The Goose Creek Masonic Lodge was built by Houston contractor W.L. Goyen in 1927. The lodge met on the second floor for 44 years, and the first floor was rented out as commercial space. The Economy No. 1 grocery store was at that location for the first few years, and Houston Lighting & Power Company had its office in the building for over 20 years. It is currently the home of Texas State Optical.

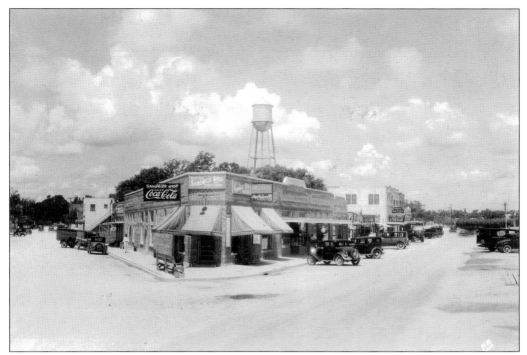

In 1927, Rufus Bergeron erected this building on the corner of Market Street and Minnesota Street, which anchored the east end of the old Baytown business district. Over the years, besides the Royal Sandwich shop, it housed the *Tri-City News Herald*, the Great Atlantic & Pacific Tea Company, the Economy No. 2 Grocery, and Dr. W.E. Marshall's office. The building was demolished in the early 1990s

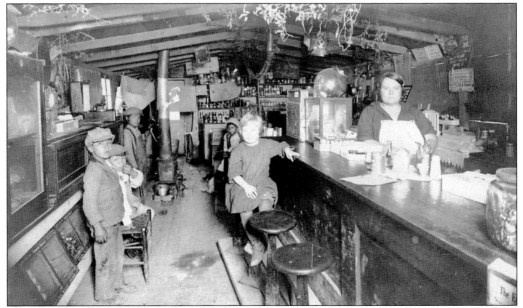

In 1928, the Bluebird Café, on Harbor Street in old Baytown, was run by Mary Alice Proctor Young, who is standing behind the counter. Her daughter, Bessie Mae, is sitting on the stool, and the other children in the picture are members of the Molina family. (Courtesy Shirley Damron.)

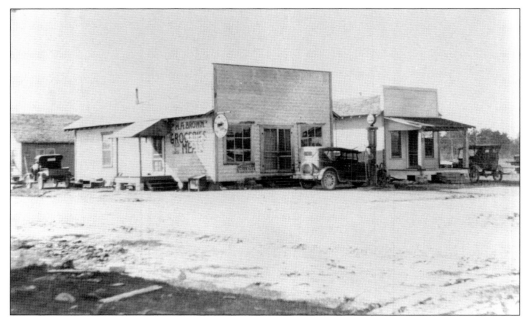

In 1928, Harold A. Brown became the only grocer in the newly established town of Highlands. He bought two lots on San Jacinto Street facing the interurban station but only stayed in business for a year. In 1929, he sold the business to George Largent, who in 1933 was still the only grocer in town. When Highlands incorporated in 1930, Brown was elected commissioner, but he resigned the following year.

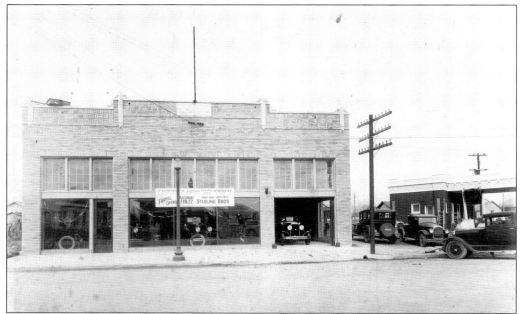

E. Aron constructed this commercial building on Texas Avenue between Pruett and Whiting Streets in 1929 and opened for business in 1930. The first occupant was the Sterling Brothers Chrysler dealership, which had its grand opening on February 22. The dealership changed hands several times through the 1930s, and by 1939, it was Jack Saunders Chevrolet. The building is still standing.

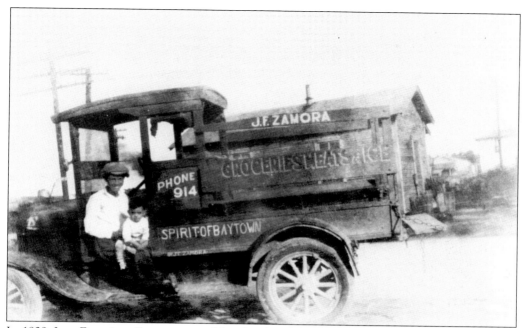

In 1929, Jose Francisco Zamora moved his family to Baytown, and two years later, he opened Zamora's Cash Store on Dayton Street at Cherry Street. He owned and operated the store for the rest of his life. He also owned the Eagle Sandwich Shop and had a delivery truck he called the "Spirit of Baytown." In 1934, he remodeled the sandwich shop into a full service restaurant, and in 1938, he opened the Cuauhtémoc, advertised as the Tri-Cities' only Mexican restaurant. Five of his sons served during World War II, and one son, Frank Archie, was killed. The Zamoras celebrated their 50th anniversary in 1955, and after a lifetime of serving his customers, Jose Francisco Zamora died less than a year later.

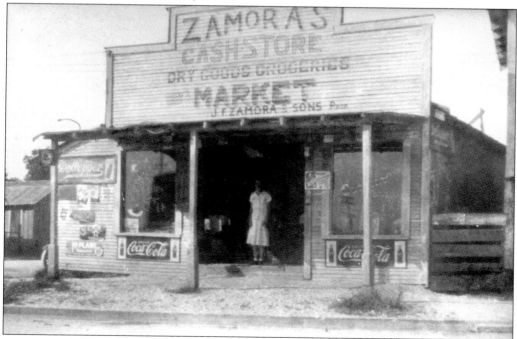

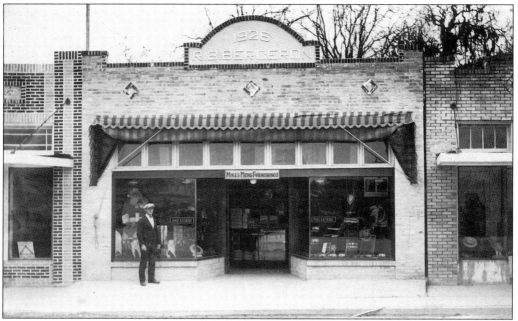

Rufus Bergeron, a bricklayer at Baytown's Humble Oil refinery, built a number of structures in old Baytown. In 1926, he built this store, which is still standing. Bergeron also served as chief of the Baytown Volunteer Fire Department and as a Baytown city councilman for several years. Mike Katribe, pictured here, had several buildings erected nearby and was a charter member of the Tri-Cities Real Estate Board. (Courtesy Vicki Fayle.)

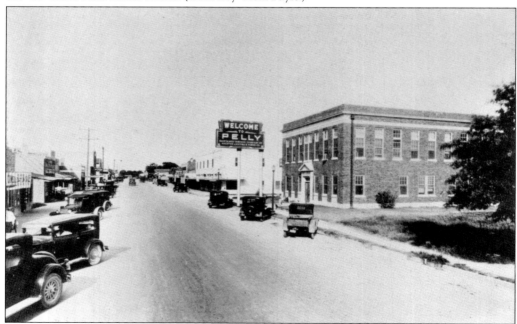

Until 1928, the Goose Creek State Bank served as the seat of government for the City of Pelly, and city council meetings were held in the Directors Room of the white two-story building seen behind the Pelly sign. When this photograph was taken about 1929, the new city hall on the right had just opened and included rooms for the Harris County Public Library as well as the post office.

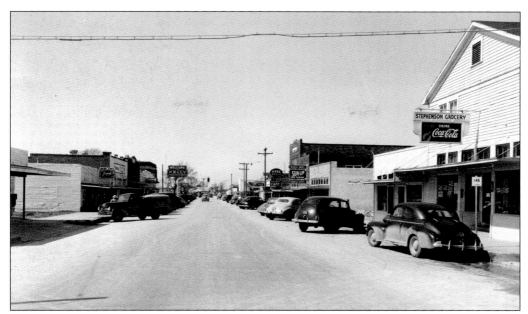

In its heyday, Pelly had a booming business district. State Highway 146, which opened in 1937, ran right through town. This photograph, taken in 1946 looking west, shows Main Street anchored by Stephenson's Grocery. Just down the street are the Russell Drug Store and the Eat-a-Bite Café, with the Bush Café across the street. The two-story brick building to the left of the "Welcome to Pelly" sign is the city hall.

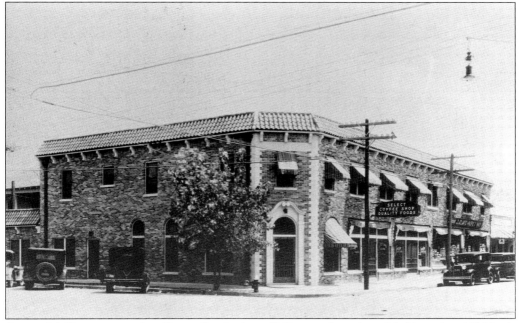

George McKinstry moved to Goose Creek about 1917 to work in the oil fields and in 1930 built the DelMont Hotel, which remained his primary residence throughout his life. The offices on the ground floor were used as doctor's offices, storefronts, the chamber of commerce, and school district offices. In 1931, it housed the Select Coffee Shop and the Great Atlantic & Pacific Tea Company. The building is still standing.

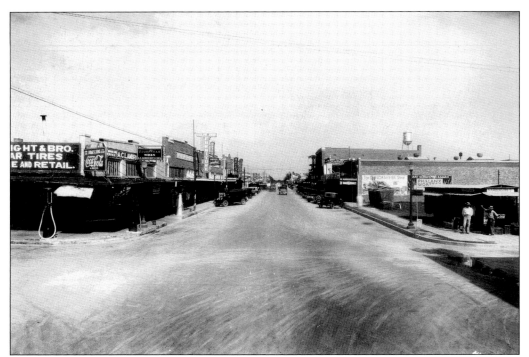

In this photograph, taken in 1932, A.C. Lambright's garage and filling station anchors the 200 block of West Texas Avenue, and the Blue Bird lunch stand is in business across the street selling 5¢ hamburgers. A year earlier, a Works Progress Administration curb project had placed blue tile street markers on the curbs throughout the business district of Goose Creek.

After operating a Gulf filling station in Pelly for a number of years, A.E. Himes opened this Gulf station about 1938. It was built just south of Highlands at the intersection of Market Street Road and Crosby Lynchburg Road, known locally as Four Corners. The man in the middle is Herbert Merchant. (Courtesy Kathy Woody.)

There was plenty of parking at the Yellow Jacket, and when customers drove in, carhops would come take their order. Besides fried chicken, it served beer and sandwiches, and orders were delivered on a tray that hung onto the driver's-side window. A full menu was also available inside that included steaks and seafood. The Yellow Jacket had a public address system that it used for broadcasting radio shows, music, and football games to the customers. (Courtesy Jeanie Rushing Currie.)

The restaurant became a popular venue for political rallies and campaigns, and the Wooster Chamber of Commerce met there for several years. During the 1980s, it underwent several name changes, and when it finally shut down in 1999, it was known as the Creole Plantation. The building is still standing on Bayway Drive. (Courtesy Jeanie Rushing Currie.)

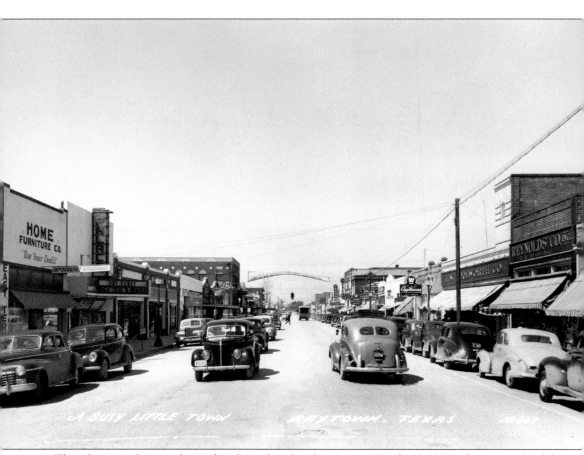

A BUSY LITTLE TOWN BAYTOWN, TEXAS

This photograph was taken a few days after the election on March 10, 1947, when citizens of the Tri-Cities voted for consolidation. Since Pelly had the larger population, that became the name of the new city until it was changed to Baytown on January 26 the following year, after which the caption written on this photograph was added. By the 1950s, Texas Avenue was fully developed, and although business districts in Pelly and old Baytown were still operating, they began to decline as Texas Avenue gained in popularity. And in a scene from the movie *American Graffiti*, teens from miles around came to town on Saturday nights to cruise Texas Avenue. In 1982, the San Jacinto Mall began to syphon businesses away, and over the next few years, many of the buildings shown on these pages were demolished. Many of the ones that remain have been boarded up, but hope remains for resurgence in the area that might bring back a piece of its former glory.

Seven

CONSOLIDATION

After 24 years owning several theaters in the area, Howard Brunson, with manager Rufus Honeycutt, opened the landmark Brunson Theater on Texas Avenue in August 1949. For decades, the Brunson remained the destination in Baytown to see first-run movies, and every Saturday morning the theater opened for what was called the Kiddie Show. For a reduced-price ticket, kids could watch a movie, a newsreel, two comedies, and ten cartoons. Besides that, Honeycutt always scheduled activities on stage such as pickle-eating contests, Hula-Hoop contests, twist contests and the like. He even figured out that the snack bar could sell snow cones made with the leftover pickle juice. When John Wayne's *Hellfighters* was released in 1968, the premiere was at the Brunson. After a period of decline, the theater closed in 1982, and today, the building houses the Baytown Tourism Department.

Erected in 1928, this building served as the Pelly City Hall for 20 years and, when the Baytown city charter was approved in 1948, continued in use as the Baytown City Hall. It served in this capacity until the new city hall on Market Street was opened in 1967. Afterward, the structure was used as a municipal building, then by several restaurants, and today houses a dentist office.

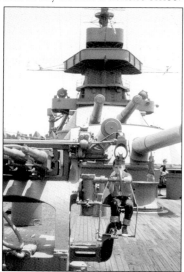

San Jacinto Memorial Hospital (above, left), dedicated to the men who served in World War II, was chartered in December 1944. Construction began in 1946 with a $1.25-million gift from Humble Oil & Refining Company. The 100-bed hospital opened in April 1948 and served Baytown until 1988. It stood vacant for several years until it was demolished in 2016. On the right is the battleship USS *Texas*, BB-35. After serving in two world wars, it was given to the state in 1948 and moored on Buffalo Bayou at San Jacinto State Park. Although not technically in Baytown, the park and the battleship have remained popular destinations for Baytown folks. In this photograph, a young Chuck Chandler is manning an antiaircraft gun.

HISTORICAL ORGANIZATIONS IN AND NEAR BAYTOWN

The Baytown Historical Museum building, constructed in 1936 as the Goose Creek Post Office at 220 West Defee Street, is designated as a recorded Texas historic landmark. The museum contains artifacts from prehistoric times to the present, telling the history of Baytown. Poems and possessions of John Peter Sjolander (1851–1939), "the Bard of the Bayou," are on display in a special room, and photographs and displays tell the story of the Tri-Cities up to the present.

The Baytown Historical Preservation Association is dedicated to the preservation of structures, artifacts, and documents that reflect and represent the history and culture of Baytown and its people through educational programs and materials that communicate our heritage. The historic 1894 one-room Wooster School, the oldest in Harris County, and the 1910 Brown-McKay House, located at the Republic of Texas Plaza, 5117 North Main Street in Baytown, are preserved and interpreted by the Baytown Historical Preservation Association.

The Chambers County Museum at Wallisville, 20136 I-10 East, features artifacts and photographs dating from the 1800s and includes a research center filled with over 2,000 books and maps for east Harris and Chambers Counties. The museum also boasts several hundred vertical files on pioneer families of the county, including the Cedar Bayou area. The resources are open to the public at no charge and researchers can stop in and visit the library without an appointment.

DISCOVER THOUSANDS OF LOCAL HISTORY BOOKS FEATURING MILLIONS OF VINTAGE IMAGES

Arcadia Publishing, the leading local history publisher in the United States, is committed to making history accessible and meaningful through publishing books that celebrate and preserve the heritage of America's people and places.

Find more books like this at
www.arcadiapublishing.com

Search for your hometown history, your old stomping grounds, and even your favorite sports team.